A BEGINNER'S GUIDE TO
SKETCHING
BUILDINGS & LANDSCAPES

PERSPECTIVE AND PROPORTIONS FOR
DRAWING ARCHITECTURE, GARDENS AND MORE!

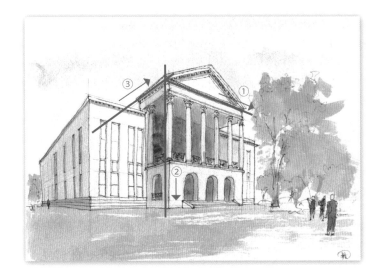

Masao Yamada

TUTTLE Publishing

Tokyo | Rutland, Vermont | Singapore

CONTENTS

Chapter 1

Depicting Facades

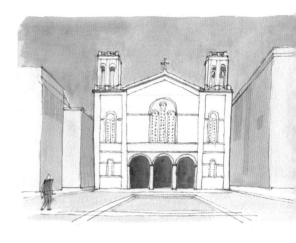

Chapter 2

Choosing and Placing Close-up and Distant Landscapes in a Sketch

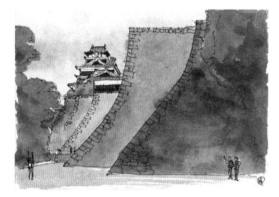

Chapter 3

Division of Ground and Sky

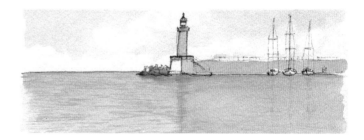

Chapter 4

Expressing Depth in One Direction

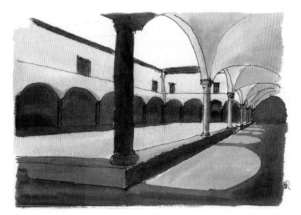

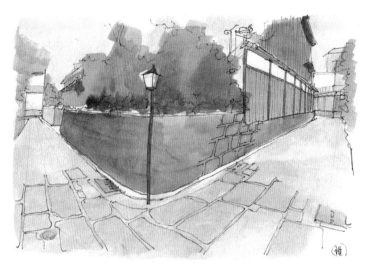

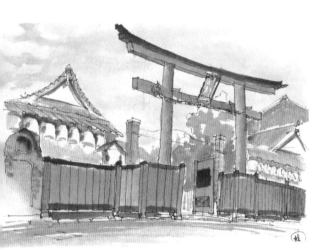

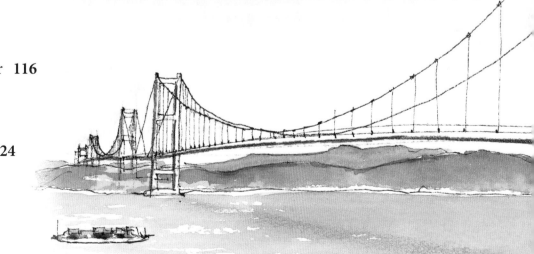

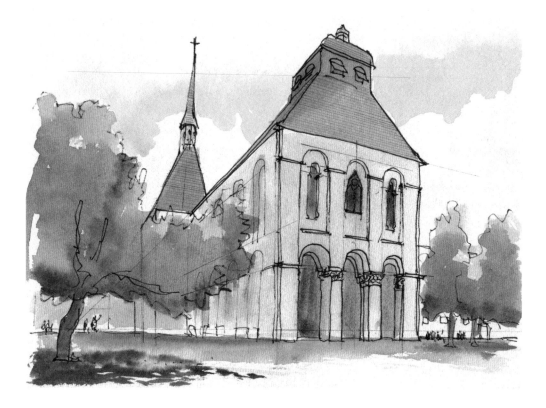

Why I Wrote This Book

Are you creating underdrawing sketches without much thought?

My aim is to shed light on the initial stages of creating sketches. Even when a drawing is colored using watercolors or colored pencils, some kind of initial sketch is usually done with a pencil before adding any color. It is the quality of those first few pencil lines you sketch that are critical to the success of your drawing.

Depicting the exterior of a building by combining simple shapes

Whether a building has a complex exterior or a simple one, it is best that you stand facing it and sketch what you see. The uneven shapes and complex ornamental surfaces of a building often make it difficult to know where to start.

Although quick rough pencil sketches can be used to give a general idea of a building's size and shape, a combination of basic shapes such as rectangles, triangles, circles and curved lines drawn on top of a rough sketch is the approach I recommend to define the main elements of a building. Drawn at the intitial stages of a sketch, the lines of these basic shapes are ideal for expressing the exterior of a building before any details are added or color is introduced to the drawing. I hope this book will help you learn how to use combinations of simple shapes to define the elements of the subjects you want to draw, be they buildings or other subjects, and to guide you in the order in which the shapes should be sketched.

It is not uncommon for the exterior of a building to be left-right symmetrical. In the initial stage of sketching, it is advisable to create balance by adding a central line in pencil where the axis of symmetry is located so that other shapes can extend around it.

Drawing scenery with depth depends on the point of convergence

It is common for subjects that align with straight elements, such as roads or riverbanks, to have an expression of depth. The direction of the important lines that meet at a point far in the distance are determined by the first few lines in a sketch. You may think that you can begin by just drawing and that it is fine to fix the important lines later if you need to. The answer to that is "no." The place where the lines come together is referred to in this book as the "point of convergence" (also known as the vanishing point), and this point is key because it determines the entire composition. Once you have started sketching, it is not possible to move the point of convergence. This point needs to be fixed at the start of a drawing, depending on the subject, so how you begin is crucial.

The first line decides the outcome of the composition

When you start sketching, you will most likely have a rough idea of the final composition. It is critical to decide in your composition how to divide the main elements into large zones (called classifying and placing), for example, the sky and sea or foliage and ground. The first two lines that you sketch generally determine the composition, so how you begin is very important. In this book, I use specific subjects to explain which line you should start sketching first and where, and what the purpose of this line is. The order of drawing the lines is very important. Although you may often start by drawing two lines together, there are instances where you draw them from the left or from the right. There are also some examples where the lines have to be drawn in a strict order, such as for entrance steps (see page 118), but for most compositions, if you are sketching a group of lines, there is a preferred order. The purpose of this book is to help you understand that.

In this book, I have presented my explanations in seven chapters, each introducing a different theme. The book is structured so that you do not have to start reading from the first chapter. However, there are some topics that appear in Chapter 5, such as sketching subjects with multiple points of convergence, that may be too difficult for beginners. That said, I have included some examples of composition and placement you may want to draw, as I think they make a great reference.

Please keep in mind that the first few lines you draw are very important and that each line has a meaning, so make good use of them when sketching!

—**Masao Yamada**

Drawing Buildings:
Which Part to Draw, and From Which Vantage Point?

Even when drawing the same building, the drawing can change significantly depending on the placement and perspective used.

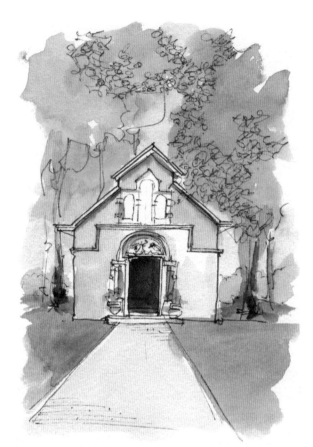

● **Facades Close Up**

Start by drawing the facade of a building from close up. This is the easiest way to draw and is ideal for beginners.

↓

Chapter 1 Depicting Facades
Chapter 3 Division of Ground and Sky

● **Distant Facades and Landscapes**

Drawing the facade of the building from a slightly distant position, including the surrounding scenery.

↓

Chapter 2 Choosing and Placing Close-up and Distant
** Landscapes in a Sketch**
Chapter 3 Division of Ground and Sky

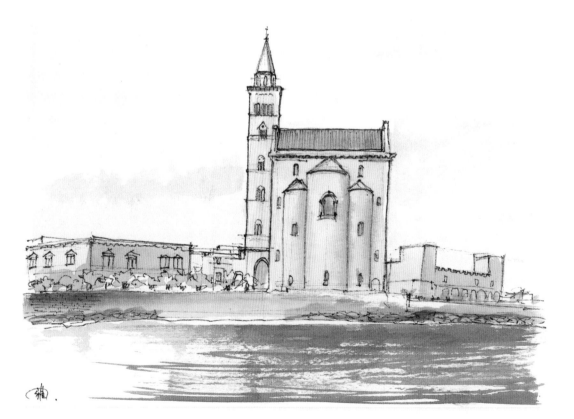

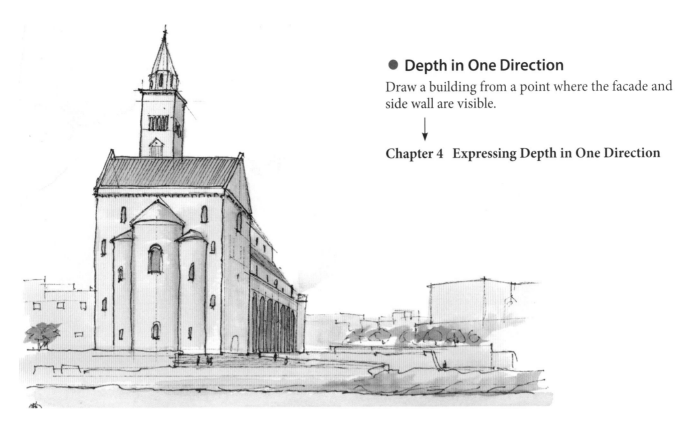

● Depth in One Direction

Draw a building from a point where the facade and side wall are visible.

↓

Chapter 4 Expressing Depth in One Direction

● Depth in Two Directions

Draw a building viewed from a corner.

↓

Chapter 5 Determining a 3D Expression with the First Two Directional Diagonal Lines

● Viewed from Above or Below

These are views from either an ant's or a bird's perspective. Once you are familiar with these types of views, you will be motivated to sketch them.

↓

Chapter 6 The First Sketch Lines Determine the Look of a Landscape Viewed from Above or Below

As you imitate the examples and draw pictures from various perspectives, you will gradually learn the techniques and be able to form your own style.
Have fun while challenging yourself!

Depicting Facades

In this chapter, I introduce a drawing method used mainly for sketching buildings. We will draw the facade of a building looking at it face-on. With reference to the finished drawings accompanying the instructions, I will give specific examples showing what should be depicted first in the sketch and how to express this with lines.

It is said that it takes more time to sketch buildings than other subjects. This is because, apart from the overall shape and complexity of a building, there are various detailed elements, including the windows, the entrance and the eaves, to consider. It takes time to add in any elaborate designs and ornamentation. For example, classical-style buildings have additional embellishments like sculptures and ornaments. In order to express these details, it is important that the framework is first accurately depicted. If the exterior walls are square, the appearance will be determined by the ratio of length to width. Another point for symmetrical buildings is that it is essential to have a strong awareness of the axis of symmetry.

The buildings that I want to show you how to draw here are not like most. They have unique characteristics, such as a dome or a triangular roof. That is why I recommend creating an initial sketch that is a combination of squares, triangles, circles or curved lines.

In principle, you should use a pencil or similar tool and depict the overall form with rough lines. If you use a pencil, you can draw in shading to depict surface areas, although I will not do that here. However, it is surprisingly difficult to roughly depict a form using lines, so I have also included rough sketches at the beginning of the steps to demonstrate how to get an approximate idea of the form and size of a subject. Although it is an underdrawing, having such a rough sketch reduces the burden considerably compared to jumping straight in to use lines to depict a form.

Sketching with Squares and a Central Line

Viewed face-on, the three
vertical lines are equal.

It may seem too simplistic to stand front and center and draw the exterior of a building. But this is by no means the case. A frontal view can create a very attractive drawing. Here, I will explain how to begin the sketch, positioning the base line of the building at the top of the steps. You need to keep the center line in mind while drawing.

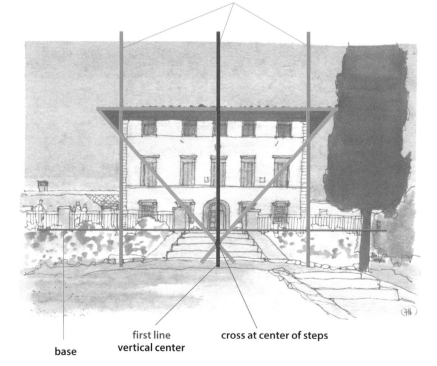

base

first line
vertical center

cross at center of steps

Sketch Line Order

→ Line direction

1 Rough positioning

Before starting the sketch, draw a rough outline on your paper to show the position and size of the building.

This rough outline will be present throughout the sketch, but to avoid complicating the sketch it is not shown from step 2 onward.

2 Start

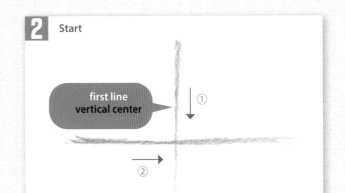

first line
vertical center

Draw the center (vertical) line in the middle of the paper, and then add the base (horizontal) line of the building.

3

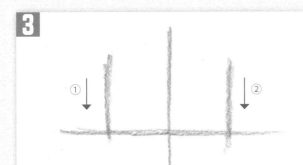

This is an important step. Look carefully at the height-to-width ratio of the rectangle representing the facade of the building, and then draw two vertical lines.

4

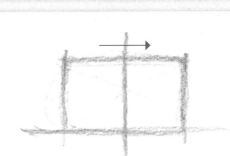

Determine the size of the building rectangle and draw a line. If the height-to-width ratio of the rectangle is incorrect, it will be difficult to rectify later.

5

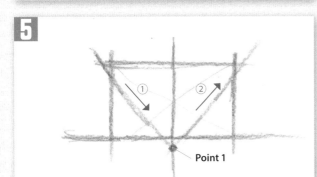

Point 1

To draw the diagonal lines of the eaves, mark point 1 on the center line, halfway up the steps. Draw two symmetrical diagonal lines from the center line.

6

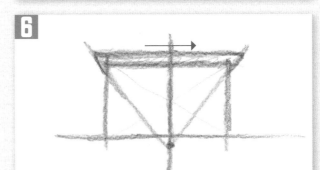

Draw a horizontal line that takes into consideration how the eaves jut out. This gives the flat facade a sense of depth, which is characteristic of a building.

7

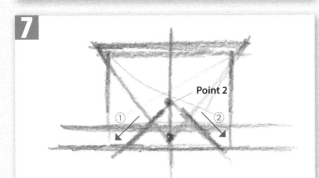

Point 2

Sketch some lines to express the shape of the steps. Mark point 2 on the center line and add diagonal lines to define the width of the steps. The position of point 2 does not have to be exact.

8

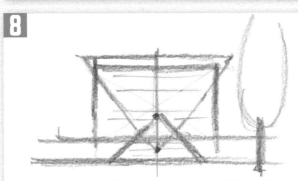

Roughly sketch the size of the tree on the right and add faint auxiliary lines as a guide for the placement of the windows. Once you have done this, it will create an adequate underdrawing.

Depictions Using Triangles

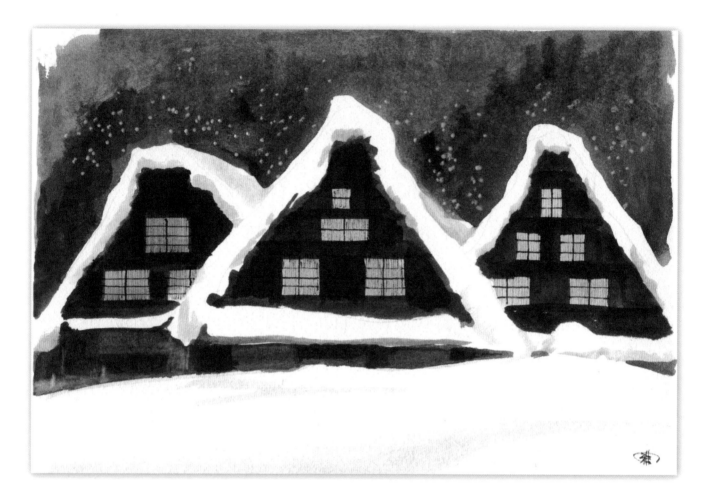

Here, we will draw a group of three *gasshou-zukuri* houses, part of a World Heritage site in Hida, Gifu Prefecture.

As the three buildings are built almost parallel to each other, this composition is done looking face-on at the exterior gable ends (triangular walls).

I have chosen a composition placing the impressive middle building at the center of the paper to create a strong sense of equilibrium.

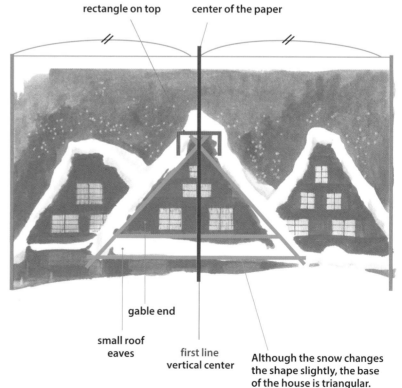

rectangle on top center of the paper

gable end

small roof eaves

first line vertical center

Although the snow changes the shape slightly, the base of the house is triangular.

Sketch Line Order

1 Rough positioning

Before starting the sketch, roughly draw the shape of the three triangles. Make the lines as faint as possible to make it easier to erase them later, but make sure you can still see them.

This rough outline will be present throughout the sketch, but to avoid complicating the sketch it is not shown from step 2 onward.

2 Start

first line
vertical center

Begin to draw the shape of the center building. Because it is symmetrical, start with a center line.

3

This step is very important. The diagonal line will determine the slope of all the roofs on the buildings.

▶ The slopes of the roofs are approximately the same.

4

Draw a diagonal line on the right, making sure it is symmetrical across the center line.

5

Draw a horizontal line at the base of the triangle. There is a small roof under the gable ends and this corresponds to the line of the eaves.

6

① ②

The part that corresponds to the top of the roof is not a simple triangular corner. Clarify the horizontal roof you began step 5.

7

Draw the triangular shapes on the left and right in the same way.

8

Add horizontal and vertical auxiliary lines to give a clue as to the position of the square *shoji* windows. After doing this, the underdrawing is adequate.

Dividing a Pentagonal Facade into Squares and Triangles

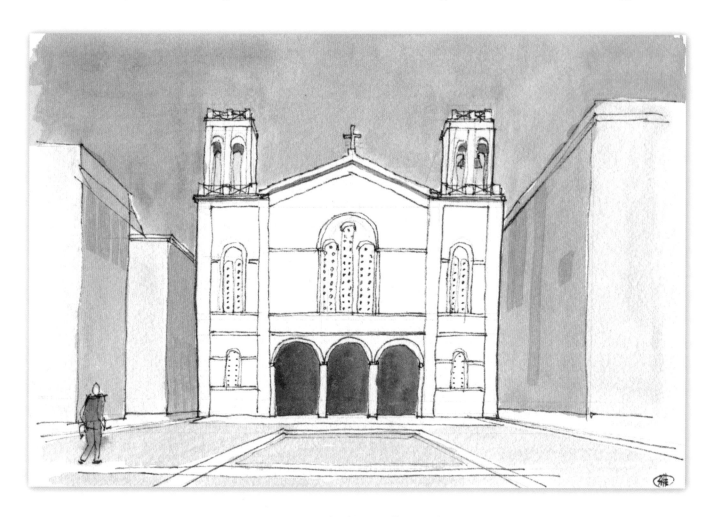

Depict this as a tall rectangle. Treat this as a triangle.

Here, we are going to draw a church viewed face-on from across a square. It is a neat and symmetrical building. Because the roof is partially visible, the shapes of the building elements are comprised of a combination of a pentagon and rectangles. The pentagon does not have to be drawn to start with, as the basic shapes here comprise a triangle and three rectangles.

▶ Try to get into the habit of depicting subjects as a combination of simple shapes.

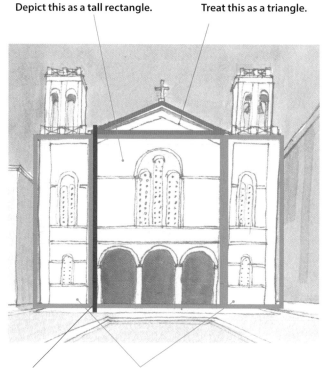

first line tall, thin rectangles of the same size

Sketch Line Order

1 Rough positioning

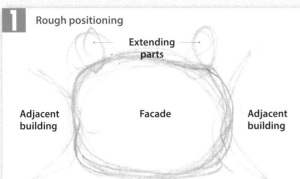

Extending parts

Adjacent building Facade Adjacent building

Before starting the sketch, roughly indicate the size of the main building in pencil before adding auxiliary lines for other parts.

This rough outline will be present throughout the sketch, but to avoid complicating the sketch it is not shown from step 2 onward.

2 Start

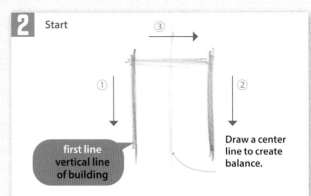

③

① ②

first line vertical line of building

Draw a center line to create balance.

Draw the center line for the most important central rectangle first, and then draw the two vertical lines and add the top line.

3

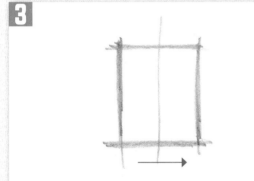

Draw a horizontal line at the bottom to create a rectangle.

4

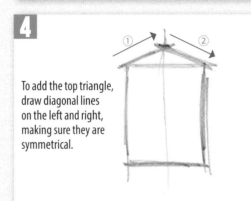

① ②

To add the top triangle, draw diagonal lines on the left and right, making sure they are symmetrical.

These six lines, including the triangle at top, determine the basic shape of the exterior.

5

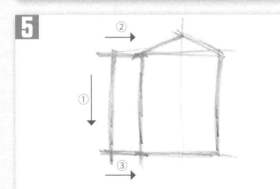

② ① ③

Add elongated rectangles on each side of the main rectangle for the bell towers. Start with the rectangle on the left.

6

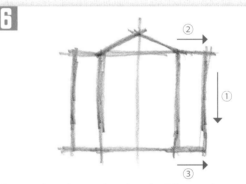

② ① ③

Draw an identical rectangle on the right of the central rectangle to create matching walls for the facade.

7

① ② ③ ④ ⑤ ⑥

Add small towers on top of the elongated rectangles. Make sure the height of each is in proportion to its base and the height of the central triangle.

The auxiliary lines used to convey perspective are different from those described so far. See Chapter 4 for a more detailed explanation.

8

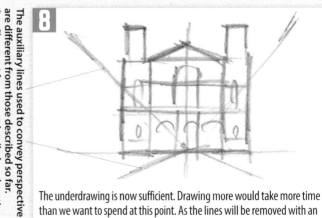

The underdrawing is now sufficient. Drawing more would take more time than we want to spend at this point. As the lines will be removed with an eraser after tracing with a pen, it is better to have as few as possible.

Depictions Using Squares and Circles

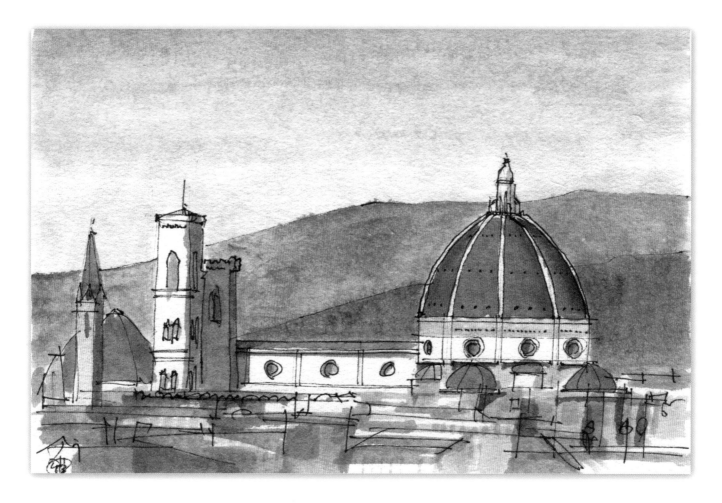

This is a distant landscape that includes Florence Cathedral in Italy. The rounded dome is striking. Its shape can roughly be described as a combination of a circle and a square. The first thing to do is to get an idea of the size of the dome and where it is positioned.

13 : 5

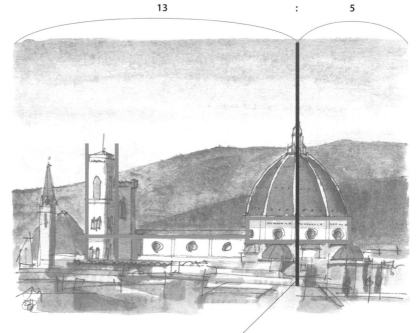

first line

Sketch Line Order

1 Rough positioning

Before starting the sketch, roughly draw the main shape and decide where to place the dome.

2 Start

first line
vertical center

Determine the axis that will form the center of the dome. Select the position of the square of the golden ratio in respect to the horizontal direction of the paper.
* It is quite far to the right.

* 13:5 See page 34 for reference.

3

Draw the horizontal rectangle visible at the base of the dome. Try to make it symmetrical.

4

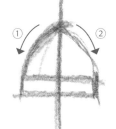

Decide the curve and size of the dome. This step is important. It is a key part of the building's outline.

5

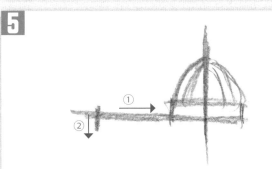

Extend the building to the left, using the size and shape of the dome as a guide. Start by drawing a horizontal line from the side.

6

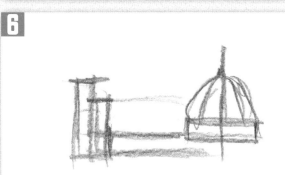

Draw two rectangles to depict the two towers on the left, the right one shorter than the one on the left.

7

Add the outlines of the surrounding buildings and other objects, keeping an eye on the balance in relationship to each.

8

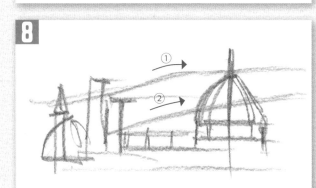

Add the gentle mountain ridge visible in the background to complete the underdrawing. It is fine if you want to add more lines.

Depictions Using Squares and Triangles: Placement of Edges

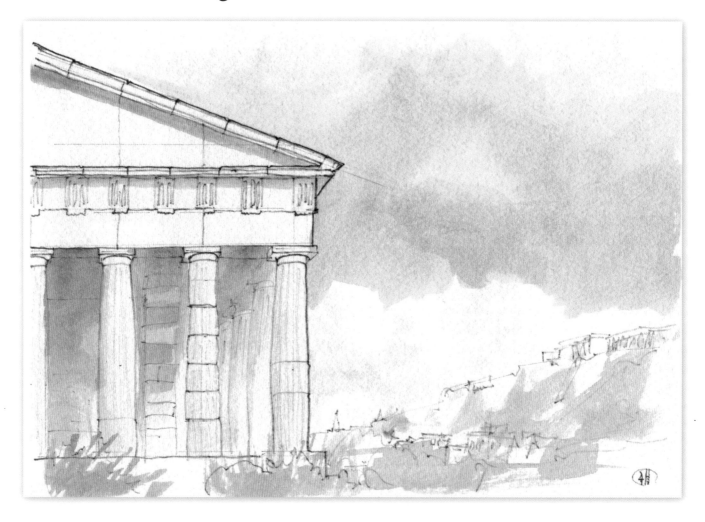

This picture depicts the ruins of a Greek temple looking face-on. While the entire facade can be drawn, it may also be effective to portray a part of the facade close to the edge of the paper, as shown here. Draw a combination of a square and a triangle, the square first, and then the triangle of the roof. In step **3**, the key is to determine the space between the top and bottom lines so that it forms almost a square shape. Note that in this example, the important lines have been drawn without fixing the rough position of the exterior shape, but you can add a rough outline of the positioning if you wish.

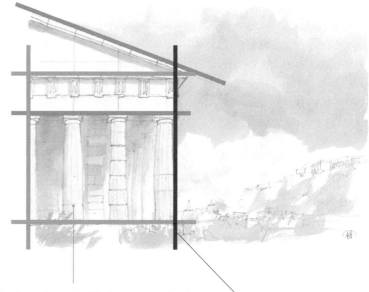

The shape formed with the green and red lines is almost square, so make use of this.

first line

Sketch Line Order

1 Start

Start by deciding on the position of the right-side edge of the facade wall against the width of the paper. Here it is slightly left of center. It does not have to be exact.

first line
edge of wall

2

Determine the section that will form the almost square facade. Start by drawing a line at the top edge.

3

Square

Draw the bottom line. Determine the position, making sure to check that it is square.

4

Using the square as a guideline, imagine a triangle placed on the top. Draw a diagonal line, paying close attention to the angle.

The corners of the triangle and the square do not match, but this is fine.

5

Divide the square with lines. First, focus on the wall section.

6

Draw a number of repeating vertical lines to determine the position of the columns. Here, the first line decides the width of the columns.

column width

7

Draw lines to mark the row of columns to the left. If you draw the shafts of the columns first, the spacing between them will be more even.

column shafts

8

Add the rough shapes of the decorations at the top of the columns and the hill in the distance. These auxiliary lines are sufficient for the underdrawing.

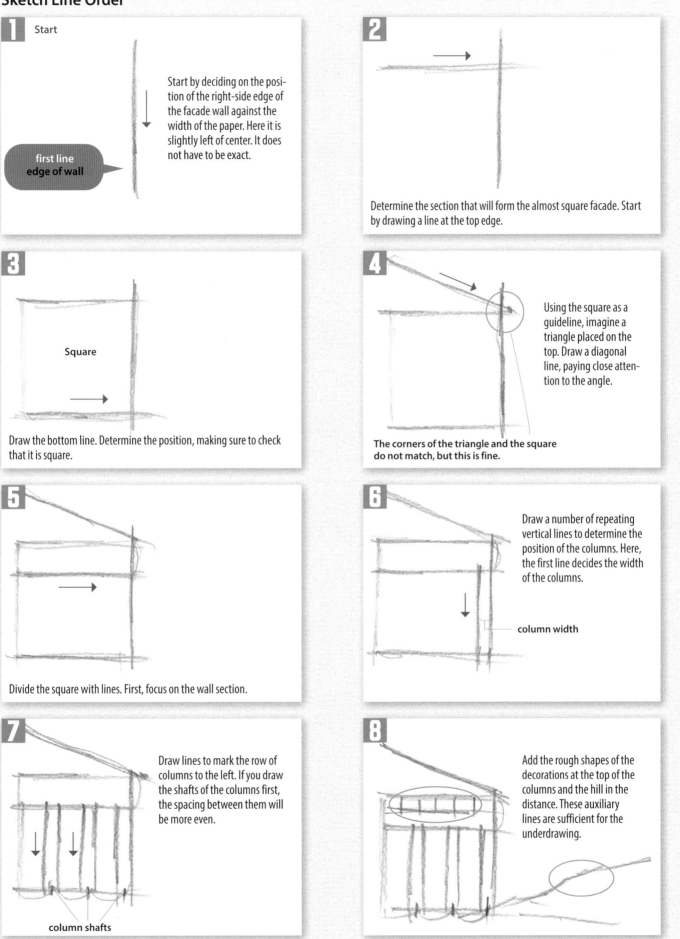

Choosing and Placing Close-up and Distant Landscapes in a Sketch

What to Omit in Close-up and Distant Landscapes

When some people look at scenery, they immediately start drawing. But as the size of drawing paper is fixed, it is necessary to consider what you want to put on it. After drawing for a little while, you may realize that some of the objects you wanted to include do not fit on the page. Thus, before starting drawing a landscape, it is important to decide what you want to express and what part of the landscape you want to include.

When drawing a landscape that combines both close-up and distant views, your choice is critical, particularly how to include background on the paper. In a distant landscape, the elements are positioned according to a large scale, such as the ground or horizon. If you draw the horizon first, it will affect the shape and placement of the various elements added in the foreground.

Focusing only on a close-up landscape ▶
For expressing a beautiful group of buildings, see page 22.

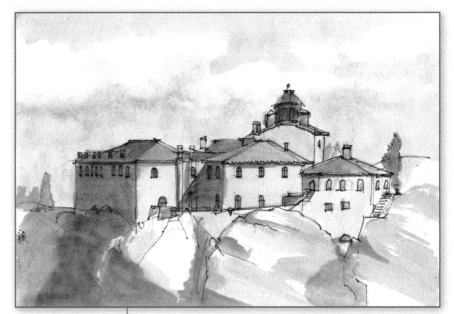

Contrasting close-up and distant landscapes ▶
For creating a striking contrast between the buildings on the rocks and the surrounding plains, see page 24.

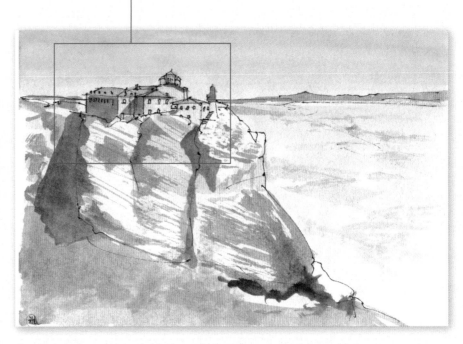

Drawing Only a Close-up Landscape

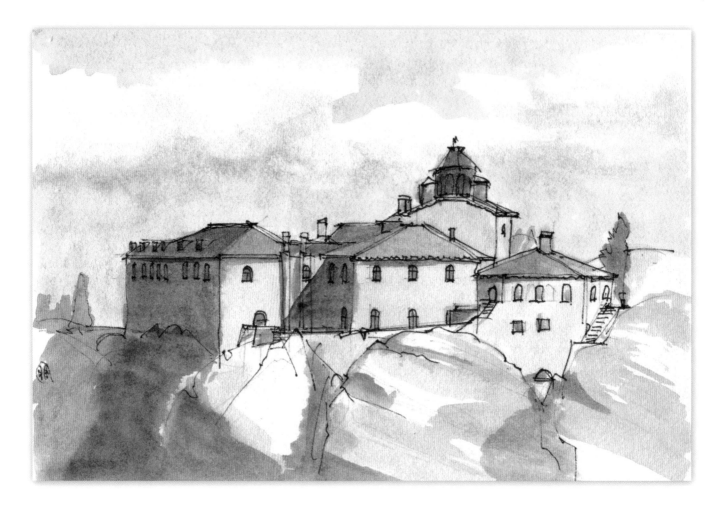

Instead of choosing a composition that contrasts the close-up and distant landscape, an option is to draw only the close-up landscape. This subject overall is on a grand scale. If it was based on a general scale, it would probably be more a mid-distant landscape than a close-up one. This group of buildings standing on a craggy mountain, is ideal for a close-up landscape as the forms of the buildings clustered together are beautiful. Let us consider the balance of the three zones of rocks, buildings, and sky before we draw this cluster of buildings. The positional relationship of the roofs on the buildings is very important, so make sure to depict the position of the eaves.

first line

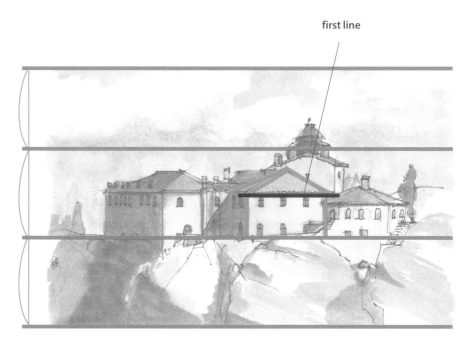

Roughly divide your paper vertically for the three sections: sky, buildings and rocky cliff.

Sketch Line Order

1 Section

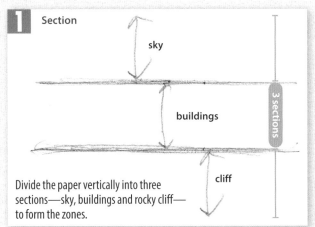

Divide the paper vertically into three sections—sky, buildings and rocky cliff—to form the zones.

2 Rough positioning

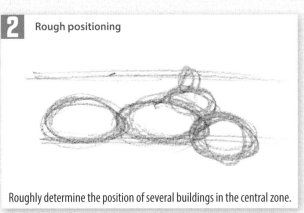

Roughly determine the position of several buildings in the central zone.

This rough outline will be present throughout the sketch, but to avoid complicating the sketch it is not shown from step 3 onward.

3 Start

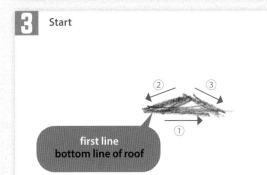

Depict the building visible in the center. Start by sketching the roof.

4

Add the exterior walls, clearly showing their position and size.

5

Using this building as a guide, sketch the outline of the building visible at top right.

6

Draw the tower. This will give the flat facade a sense of depth and gives the building a more three-dimensional appearance.

7

Draw the size and shape of the building visible to the left of the buildings being used as a guide.

8

Draw the other elements, such as the building on the right.

Contrasting Close-up and Distant Landscapes

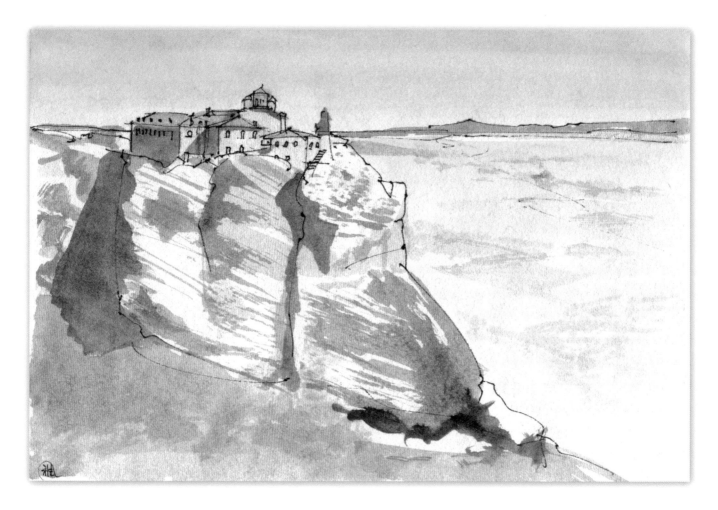

If you compare this to the previous example, you can clearly see the characteristics of each work. The contrast between the close-up and distant landscapes creates an even more striking contrast between the group of buildings on the cliff and the surrounding plains.

Both the close-up and distant landscapes need to be drawn within the limited space of the paper, so the balance between the two has to be taken into consideration. A natural composition would be a view from the same height as the buildings on top of the cliff. For this, roughly divide the paper vertically into four equal horizontal sections, placing the top quarter above the horizon. Place the starting point for the cliff in the center of the red horizontal line on the paper.

The cliff starts from center of the horizontal line.

first line horizon

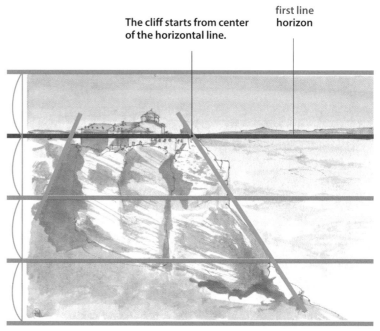

Divide the paper vertically into four equal horizontal sections.

Sketch Line Order

→ Line direction

1 Rough positioning

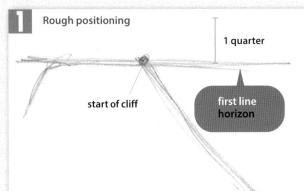

1 quarter

start of cliff

first line
horizon

Determine the position of the horizon in the top quarter. Mark the border of the cliff in the center along the horizon.

2

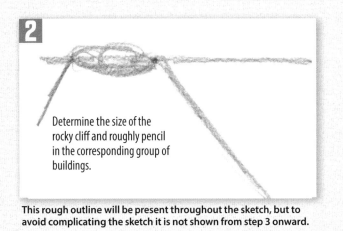

Determine the size of the rocky cliff and roughly pencil in the corresponding group of buildings.

This rough outline will be present throughout the sketch, but to avoid complicating the sketch it is not shown from step 3 onward.

3 Start

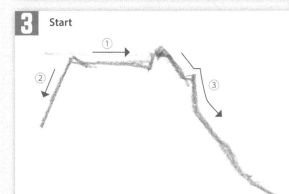

Sketch the outline of the cliff so that it is clearly depicted.

4

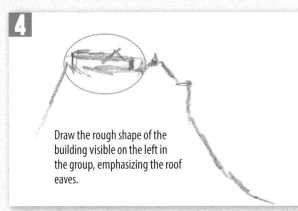

Draw the rough shape of the building visible on the left in the group, emphasizing the roof eaves.

Lines with no numbers can be drawn in any order.

5

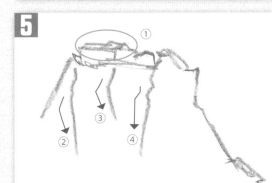

Place the roof on the building drawn in step 4, and add the main uneven ridge lines of the cliff.

6

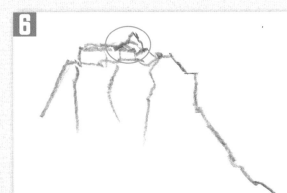

Draw the outline of the building that is taller than the others in the group.

7

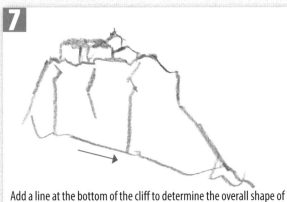

Add a line at the bottom of the cliff to determine the overall shape of the close-up landscape.

8

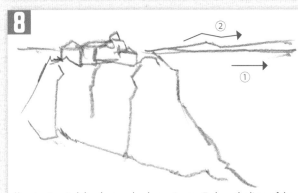

Keeping in mind the close-up landscape in step 7, draw the lines of the plains in the distance and the mountain range in the far distance.

Drawing a Sweeping Field of Flowers

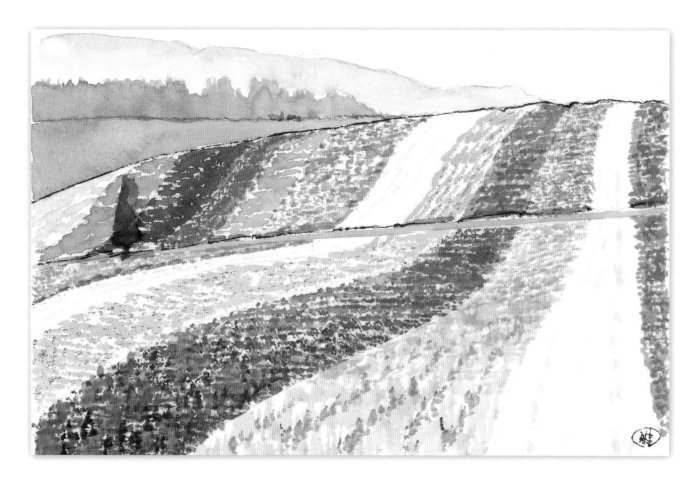

When drawing a landscape that stretches from close up into the distance, an effective technique is to create elements that form continuous bands.

A band can be comprised of anything, including a road, farm or vegetation, but it should gradually change width to match the perspective. If you want to express the undulations of the terrain, start by adding curving lines in the foreground.

first line

Divide the paper vertically into four equal horizontal sections.

Sketch Line Order

1 Start

1 quarter

first line
horizon

Determine the position of the horizon in the top quarter. Draw a horizontal line at eye level.

2

Add the contour lines of the undulating land. Draw these early on in the sketch.

3

Add the line of the mountain ridge in the far distance. Draw this early on in the sketch.

4

①
②

Make the flowers of each strip all the same type. Sketch the most prominent band first.

5

Add the line indicating a farm track running across the bands.

6

Add the curving band line on the left.

7

Add the curving band line on the right.

8

Add the rest of the curving band lines, trees and other shapes in any order. With these additions, the underdrawing is sufficient.

Drawing a Castle Visible Behind Stone Walls

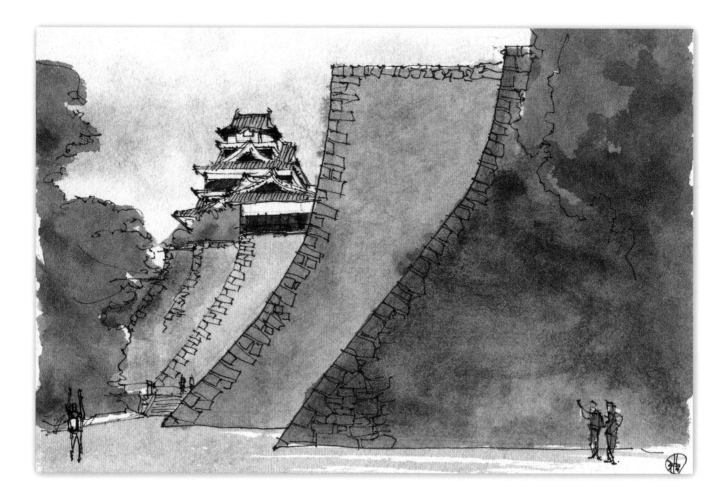

This drawing resembles the hillside Kumamoto Castle in Kumamoto Prefecture, Japan. Its unique curved stone walls were designed to prevent attackers from entering the castle. There is a keep (fortified tower) in the distance. The composition has both beauty and depth. In this drawing the emphasis is on the visible surfaces of the masonry. I have set the position so that the top corner of the second wall in the foreground is placed in the center of the horizontal line on the paper. In this way, the keep can be positioned about one-third to the left of the red horizontal line.

The keep is one-third along the left side on the horizontal.

The corner of the second castle wall is center of the horizontal line.

first line

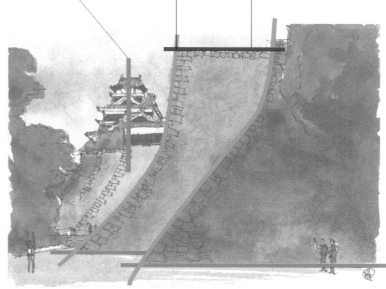

Sketch Line Order

1 Rough positioning

It is important to understand the ratio of the large mass of the castle walls. Start by determining the positional relationship between the second wall when viewed face-on, as well as the castle keep.

In steps 1 and 2, roughly mark the positions of the castle keep and walls before adding the sketch lines.

2

Add the shape of the wall closest to the front. Mark the position of the keep base.

This rough placement of lines will be present throughout the sketch, but to avoid complicating the sketch it is not shown from step 3 onward.

3 Start

first line
castle wall outline

Draw the outline of the second wall seen from the foreground, paying attention to the curve marked ②.

4

Sketch the shape of the wall in the immediate foreground. Draw a line where the wall comes into contact with the ground.

5

Continue drawing the castle walls to the left. Start with the third from the front.

6

Sketch the fourth wall.

7

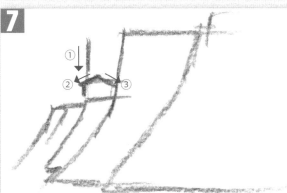

Mark the center line of the castle keep. Draw the building visible atop the third castle wall.

8

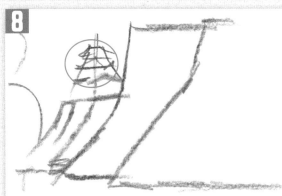

Roughly draw the tiers of the keep roof. These can be drawn in any order.

Concerning Composition

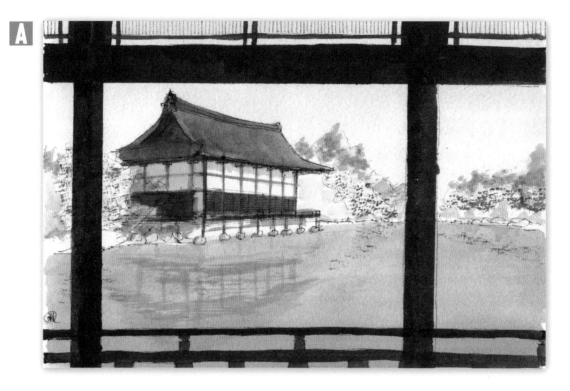

A

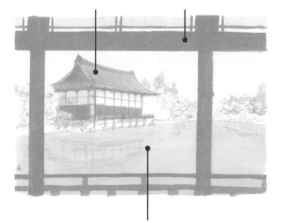

mid-distance building

close-up of columns and beams

water placed in between

Once you have mastered positioning close-up and distant landscapes, you will be able to create expansive and dynamic compositions by combining the two types. When combining the two, the question is, how should the close-up, mid-distance and distant elements be arranged on a limited paper size?

The most effective technique I recommend is to include elements that create a sense of distance between them. For example, if you place an expanse of water in between the foreground and background, you can create a composition that directly conveys a sense of perspective. This is easy to understand when you see a stretch of water.

Here are some examples. Both **A** and **B** are compositions that contrast the close-up and distant landscapes. Both include an expanse of water in between various elements to convey a sense of distance.

The difference between **A** and **B** is the way the close-up landscape is arranged. A's close-up landscape has a lattice-style silhouette formed by the columns and beams of a building. B employs the nearside bank of the pond as the close-up landscape, and this is placed in the bottom quarter of the composition.

B

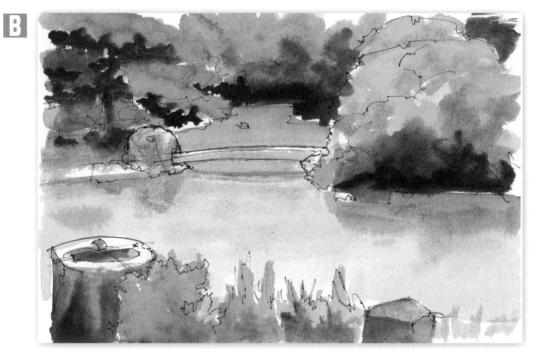

Sometimes an expanse of water or a piece of ground is not visible. In this case, an effective technique is to use a diagonal line to position the close-up and distant landscapes. By using the diagonal direction of the paper, you can maximize the size and create a sense of depth. More specifically, the close-up and distant landscapes are placed at opposite ends of the diagonal line.

water placed in between

mid-distance trees

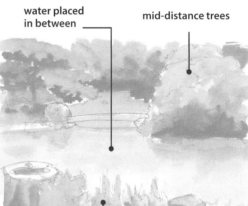

close-up of grass, etc.

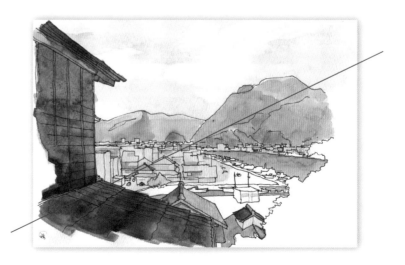

An example using a diagonal line. ▶
This is a view of a mountain in the upper right corner from a private house in the bottom left corner.

CHAPTER 3
Division of Ground and Sky

How to Divide the Ground and Sky

Start by Considering the Division

The first point to consider when drawing a landscape or other subject with a certain expanse is the distribution of ground and sky. This is important, no matter what size the paper. In general, drawing paper is used in horizontal orientation because landscapes and similar drawings extend more horizontally than vertically. However, there will be times when you may want to draw a vertical composition. Even then, you still need to think in exactly the same way about the distribution of ground and sky and first decide how to divide them.

It depends on the theme or subject you are drawing, but in principle there are three formats.

> **(1) Equal sky and ground**
> **(2) Larger sky than ground**
> **(3) Larger ground than sky**

It may seem at first glance that (1) is not interesting, as the horizon is right in the center of the paper. However, depending on the subject, this can create a neat composition. So this distribution is a valid option.

With (2) and (3), the difference is whether the horizon is above or below the center, so aside from this, if the degree of distribution is the same, you can apply the same thinking.

Division Using a Ratio of 5:8 or 8:5

One tip to help you decide the distribution of ground and sky is to use the "golden ratio," historically known as the divine proportion.

Skipping over the exact details of this, the end result should be that the ground and sky are divided into a ratio of 1:1.618 for the length of the paper in vertical orientation, or conversely 1.618:1. Having had a lot of experience drawing pictures, this is definitely a well-balanced distribution. However, these are complicated numbers, so it is not really practical to use a calculator to work out the positioning. My guide is to round the numbers up to 1:1.6 or the opposite, 1.6:1 for the ratio of distribution. To make these numbers a little simpler, this same ratio of distribution can be expressed as 5:8 or

8:5. Even with this explanation, though, the size of drawing paper varies a lot. Let us say, for example, you decide on a distribution of 8:5. It will likely be more difficult than you think to actually determine that positioning. It is always useful to carry a standard 20–30 cm acrylic ruler around with you. With small-sized paper, 8 cm along the 13 cm is where the 8:5 position is located. On larger-sized paper, you can tilt the ruler to find a 26 cm diagonal line and where 16 cm is located is the same 8:5 position. You may think that finding this diagonal line is difficult for beginners, because it is unlikely that you use a ruler in everyday life to decide the distribution of a certain ratio.

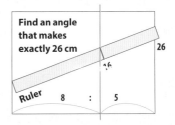

So, it is understandable if you find it challenging at first. Nevertheless, it is worth learning if you are trying to put this concept of distribution into practice in your sketches. Once you have mastered it, you will be able to position the distribution quickly and accurately.

5:7 or 7:5 and Other Ratios Work Too

Apart from the golden ratio for distribution, if you are having trouble with your composition, there are a number of other ratios that are recommended. Although I do not use it often, there is the "silver ratio." This refers to the ratio of the length to width of regular-sized copy paper.

It is a ratio of 1:1.414, or conversely 1.414:1. Here again, there are some finicky numbers after the decimal point, so it is fine to use a simple distribution of 1:1.4 or 1.4:1. A more familiar ratio for this is a distribution of 5:7 or 7:5. If the length of the paper is 12 cm, the silver ratio can be found at the 5 cm point.

Other ratios include the simple 1:2, or conversely 2:1, which can also create a solid composition depending on the subject. As it is so simple, it is easy to use.

Tips on Distribution in Various Places
This is not like the types of distribution I have explained up to now. Here, I would like to introduce a form that I sometimes use to divide the ground and sky at quite a high or low position. Expressed as a ratio, it is 5:13 or 13:5. A composition divided using this distribution will create a picture with a much larger area of ground or sky. This ratio is a rounded number, achieved by squaring the golden ratio. It is a sibling of the golden ratio.

If it can be squared, then it may also be cubed and this would be 21:5 or 5:21 rounded up. Dividing the paper using this ratio means that the section for 5 would be small, but still retain a corresponding presence. I think that the cube of the golden ratio is a valid method of division and I introduce specific examples in this book (see page 50, for instance).

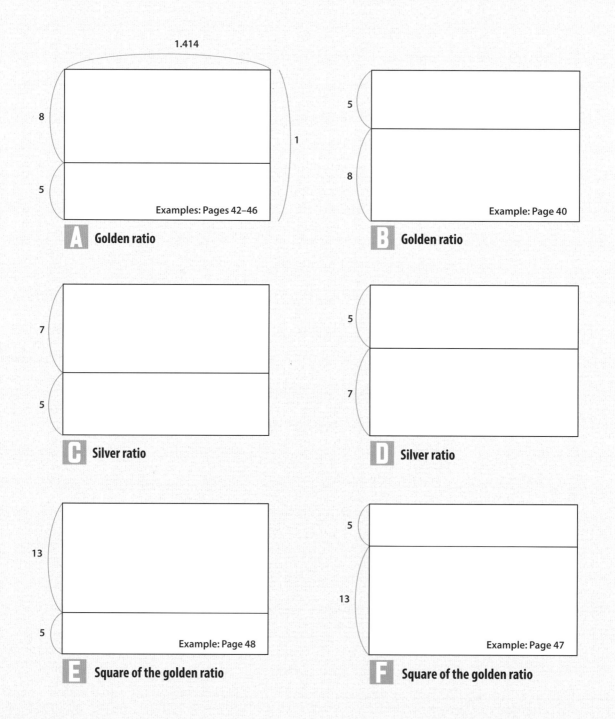

A Golden ratio
Examples: Pages 42–46

B Golden ratio
Example: Page 40

C Silver ratio

D Silver ratio

E Square of the golden ratio
Example: Page 48

F Square of the golden ratio
Example: Page 47

Recommended Divisions of Ground and Sky
The examples of distribution on the previous page are shown visually rather than with figures, but as ratios, **A**–**F** are 8:5, 5:8, 7:5, 5:7, 13:5 and 5:13, respectively. There is also the example of an even division between top and bottom (1:1), but this does not have to be visualized to be understood.

This chapter will look at the border dividing the ground and sky, but the same information can be applied to the horizontal direction of the paper, for example, when trying to decide where to place a symbolic subject on the paper. Although I introduce this in other chapters, I feel it is better to explain the principles together here and also show them visually. Those are figures **G**–**L** below.

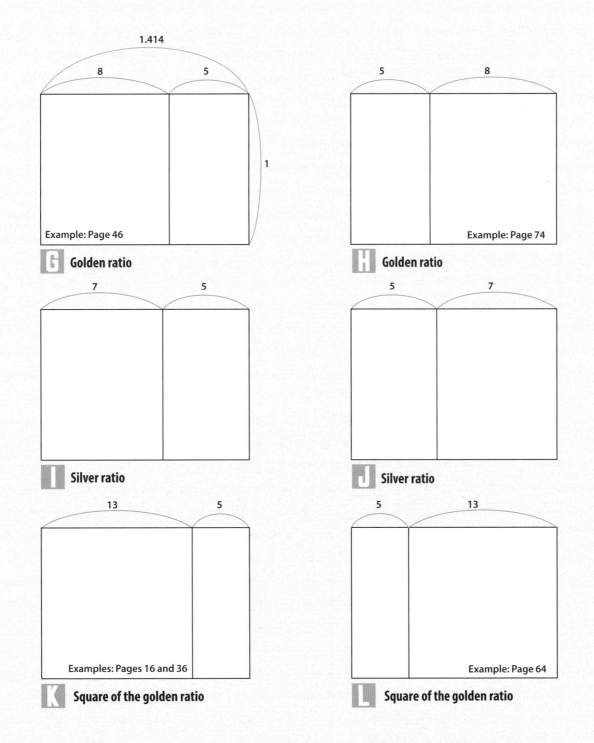

G **Golden ratio** Example: Page 46

H **Golden ratio** Example: Page 74

I **Silver ratio**

J **Silver ratio**

K **Square of the golden ratio** Examples: Pages 16 and 36

L **Square of the golden ratio** Example: Page 64

Center Division (1)

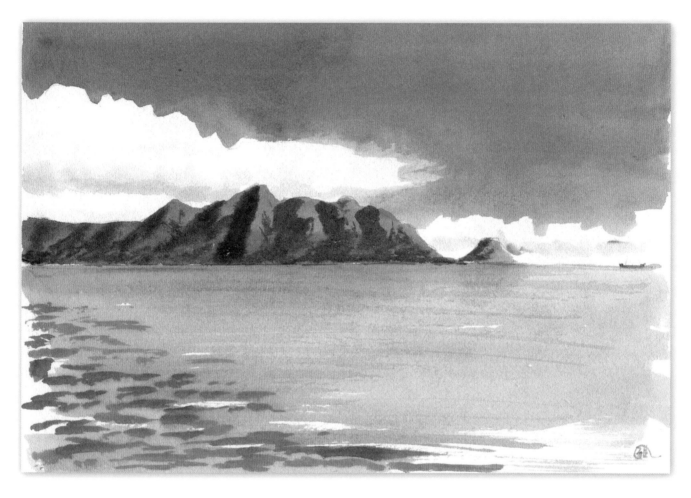

Positioning the border between the sea and the sky in the center of the paper makes for a stable image and creates a magnificent composition. You may start off thinking that a composition divided exactly in the center is unsophisticated and uninteresting. But if you add elements like a peninsula, an island or floating clouds, as in this example, the composition is anything but plain and boring. Instead, it is a composition that simultaneously achieves a sense of stability and has balanced elements.

If you want to accurately locate the central position on the vertical orientation, use a ruler to measure and identify the halfway mark. However, as this is an underdrawing, it is not a problem to use the approximate halfway position. Note that in this composition there is a triangular island visible to the right of the cape. The square of the golden ratio (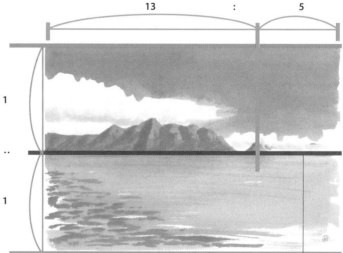 on page 35) is used to decide this positioning.

13 : 5

1

..

1

Divide the paper vertically in half at the center. Position the small island at the 13:5 divide on the horizontal.

first line
horizon

Sketch Line Order

1 Rough positioning

Before starting the sketch, draw a rough shape. Begin by drawing a line at the border between the sea and the sky and roughly depict the size of the cape's mountain ridge.

2

Mark the position of the small island on the right.

This rough outline will be present throughout the sketch, but to avoid complicating the sketch it is not shown from step 3 onward.

3 Start

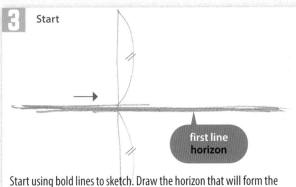

first line horizon

Start using bold lines to sketch. Draw the horizon that will form the border between the sea and sky at the center of the vertical direction of the paper.

4

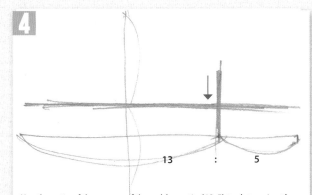

13 : 5

Use the ratio of the square of the golden ratio (13:5) to determine the island's position.

5

The island is located where the lines intersect.

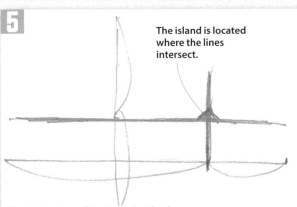

Sketch the shape of the triangular island.

6

Draw the ridge line of the cape's mountains.

7

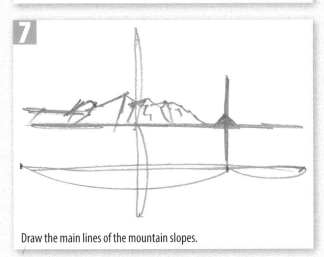

Draw the main lines of the mountain slopes.

8

Draw the rough shape of clouds and the lines on the surface of the sea in the foreground to reflect the waves in a little more detail.

Center Division (2)

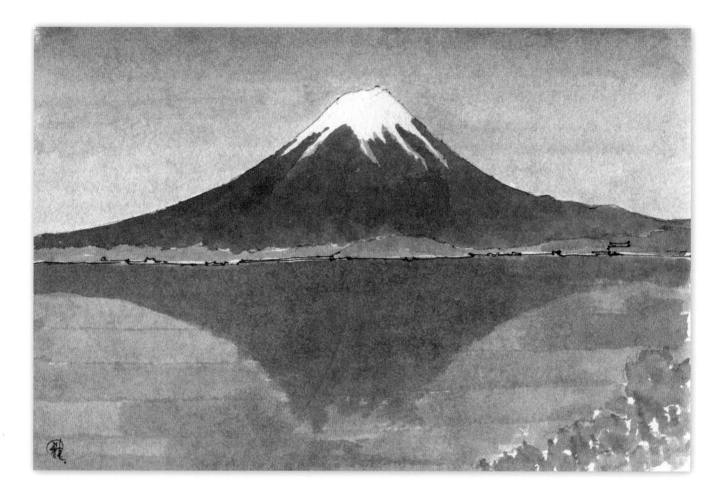

If we are going to divide the ground and the sky, let us begin by creating a composition that divides it neatly in the center. In this case, the "ground" is the surface of the water, and the changes in the reflection of the landscape and the movement of the waves are also expressed. This method of dividing the ground and sky in the center has a mechanical feel to it, but it also creates an unexpectedly rich result.

This example needs no explanation. Mount Fuji is reflected on the surface of the lake. The border of the ground and sky is at the center of the paper on the vertical direction, creating a sense of stability in the composition. The horizontal symmetry is broken by including part of the lakeshore in the bottom right.

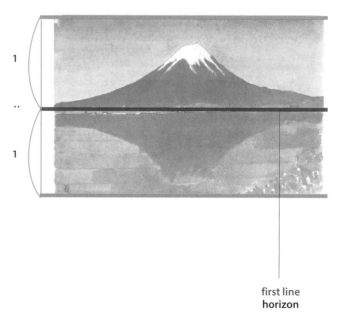

1

..

1

first line
horizon

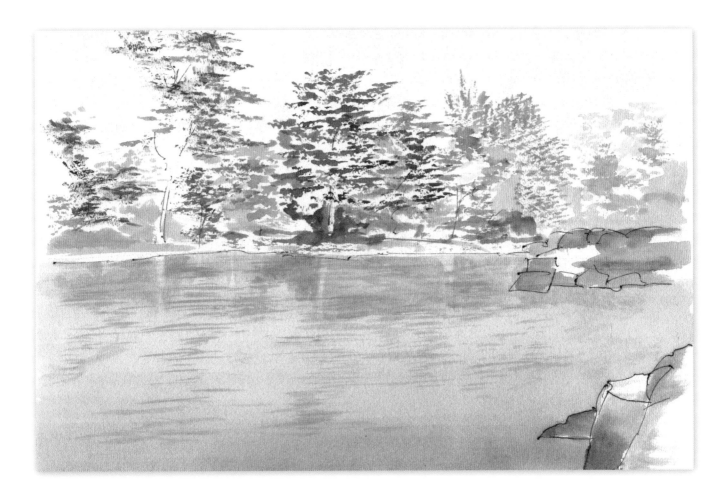

This picture is of a Japanese garden with autumn foliage. The trees are faintly reflected in the pond. In this example, as with the example on the previous page, the far bank of the pond is positioned at the center of the paper. Sections of garden rocks have been included in two areas of the picture. This not only breaks the horizontal symmetry but helps to anchor the picture.

1

..

1

first line
horizon

A 5:8 Composition

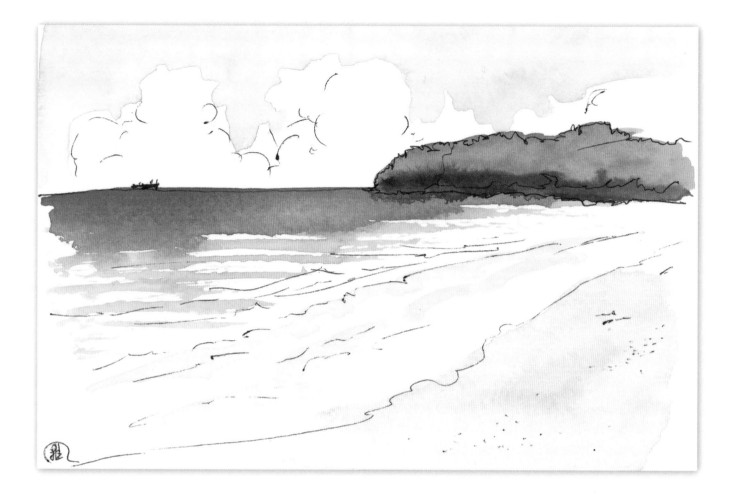

In this example, the theme is a wide expanse of sea with waves lapping at the shore. I will explain how to compose and draw this picture in a vertical direction, divided in a non-central position.

First, choose the method you prefer to divide the ground and sky in the section above the center. I recommend a composition of 5:8. Here, the composition is a ratio of 5 for the sky above the horizon and a ratio of 8 for the surface of the sea.

If instead of 5:8, the sky-to-sea ratio was drawn at 8:5, the emphasis in the picture would be on the sky rather than on the beach.

first line
horizon

Sketch Line Order

1 Rough positioning

Before starting the sketch, roughly draw the overall positional relationships. Begin by marking the position of the horizon and drawing the size of the cape visible on the right.

2

Continue by fixing the position of the shoreline.

This rough outline will be present throughout the sketch, but to avoid complicating the sketch it is not shown from step 3 onward.

3 Start

5

8

first line
horizon

The first sketch line is the horizon. Draw a horizontal line at the 5:8 point from the top of the paper.

4

tip of cape's position
(horizontal center of the paper)

Roughly mark the position of the tip of the cape using a vertical line.

5

① ②

Sketch the shape of the small hills on the cape.

6

②

①

Sketch the shoreline and arc-shaped beach.

7

Sketch the position of the incoming waves.

8

Roughly sketch the clouds in the distance, looking toward the horizon. This is enough for the underdrawing.

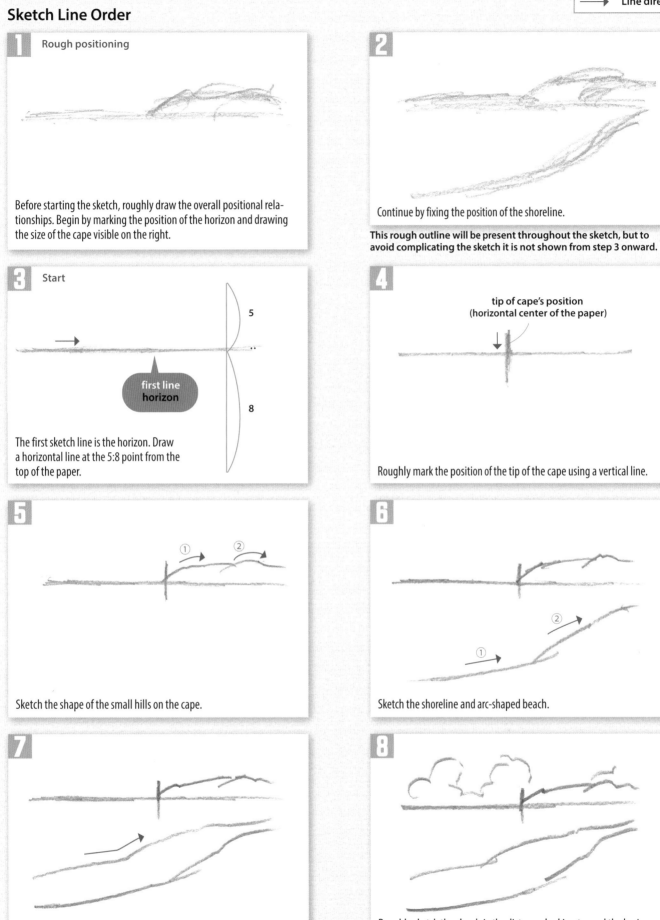

An 8:5 Composition (1)

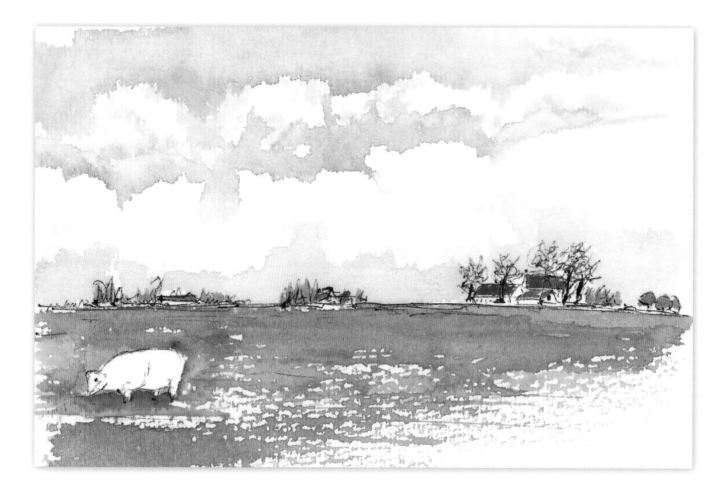

This is an example of a composition using an 8:5 ratio instead of the opposite, 5:8. Both types of ratio use the vertical direction of the paper, with the ratio here being 8 for the upper part and 5 for the lower part.

In general, when looking at landscapes, the area of the sky is larger than the area of the ground. One way to express the expansive sky is to set the horizon ratio as 8:5, with 8 being the sky and clouds and 5 being the meadow.

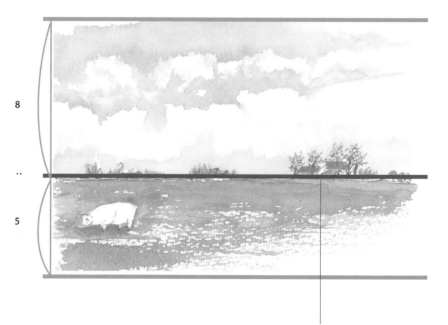

8

..

5

first line
horizon

Sketch Line Order

1 Rough positioning

Before starting the sketch, roughly sketch the composition, marking the area the land should take up.

2

Roughly draw the clusters of clouds, showing where and how they appear.

This rough outline will be present throughout the sketch, but to avoid complicating the sketch it is not shown from step 3 onward.

3 Start

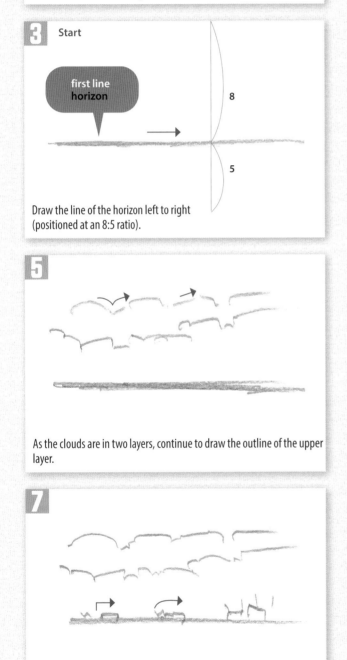

first line
horizon

8

5

Draw the line of the horizon left to right (positioned at an 8:5 ratio).

4

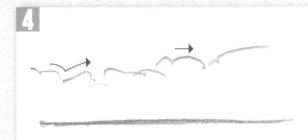

Draw the top outlines of the clouds.

5

As the clouds are in two layers, continue to draw the outline of the upper layer.

6

A number of houses are visible. Roughly draw the shape of the houses on the right.

7

Roughly draw the outlines of the other houses.

8

Rough out a cow grazing in the left foreground.

An 8:5 Composition (2)

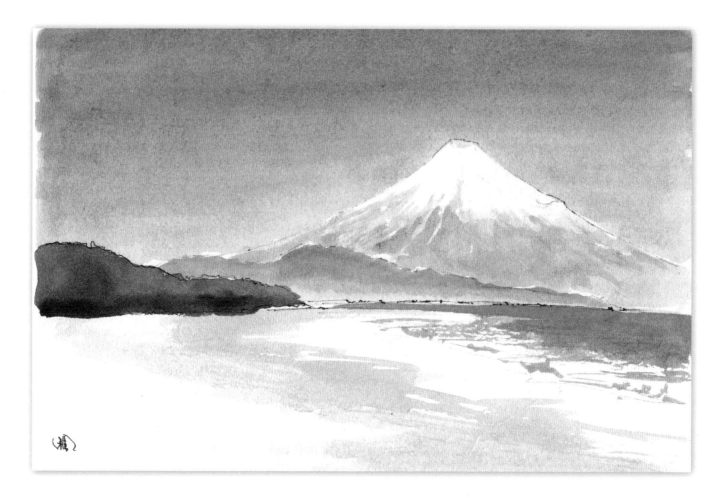

This is another example of a composition drawn with an 8:5 ratio. When drawing an iconic mountain like Mount Fuji, there should be a broad sky to highlight the mountain. The ratio of the sky should be larger than the ground, in this case the beach.

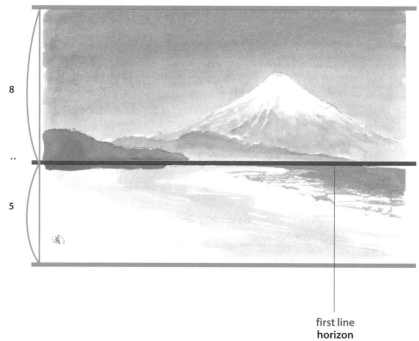

8

..

5

first line
horizon

Sketch Line Order

1 Rough positioning

Before starting the sketch, roughly draw the shape of the mountain, horizon and other subjects.

This rough outline will be present throughout the sketch, but to avoid complicating the sketch it is not shown from step 2 onward.

2 Start

first line
horizon

Draw a horizontal line for the horizon at a position of an 8:5 ratio.

3

Sketch a line to mark the crater at the top of Mount Fuji.

4

Draw a curve on the left from the summit to the foot of the mountain. This is an important line, so draw it carefully.

5

Draw a curve downward to the right that creates symmetry with the line in step 4.

6

Draw the curve of the beach.

7

For the superimposing mountains in the distant landscape, draw the ridge line of the mountain in front of Mount Fuji.

8

Draw the ridge line of the mountains in the background. These lines are sufficient for the underdrawing.

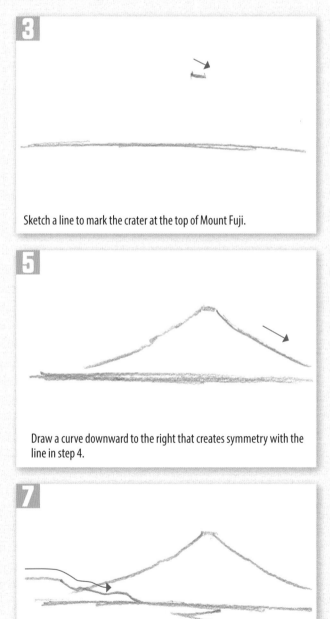

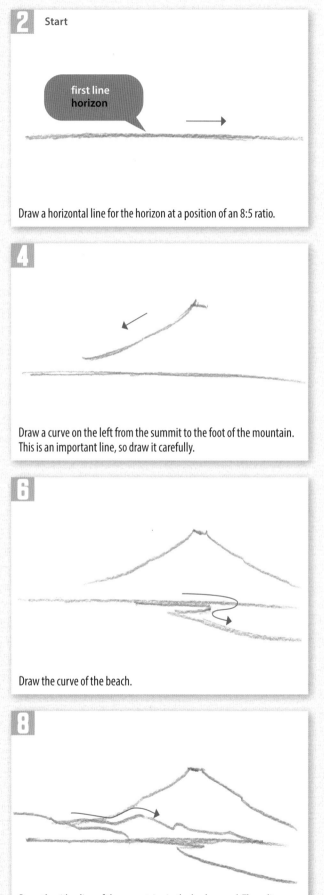

Position of the Horizon: Expansive Sky vs. Expansive Sea

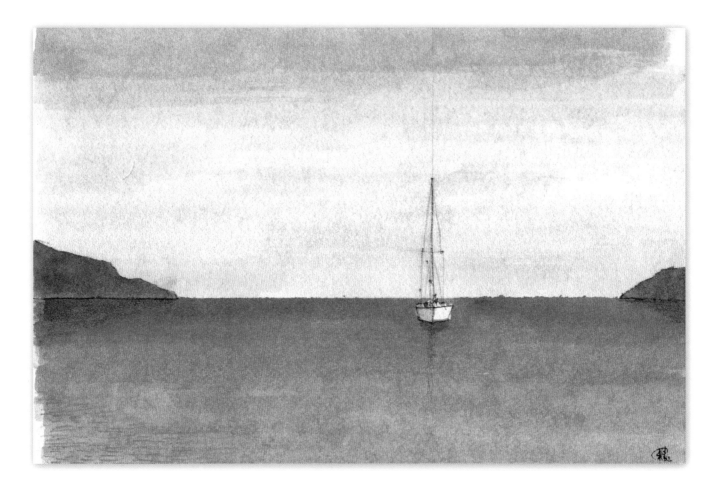

This example, depicting an expansive bay and a solitary boat, has a very simple composition. The ratio of the border between the sky and the sea (horizon) is 8:5.

So far, we have looked at examples of 8:5 or 5:8 compositions in vertical orientation, but in this drawing the white boat is placed not only on the vertical but also on the horizontal of the 8:5 ratio. It is a picture that makes full use of the 8:5 ratio.

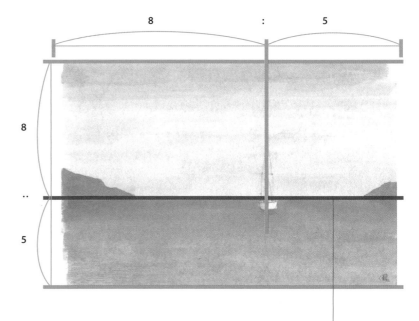

first line
horizon (sea level)

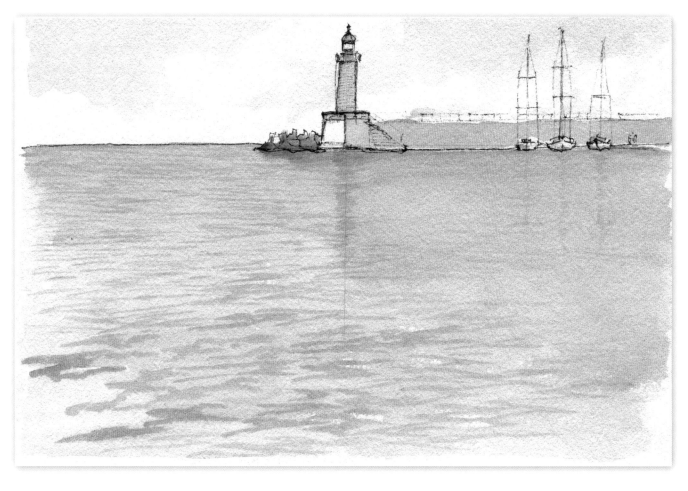

It is also possible to create a composition with a ratio of 5:13 that places more emphasis on either the sky or the ground or, as in the example here, a contrast between the sky and the sea.

There is a lighthouse at the edge of the breakwater in the harbor. The surface of the sea has been made as wide as possible to allow the reflection of the lighthouse and the ripples of the waves in the harbor to be drawn. The result is an extremely expansive sea.

The 5:13 ratio (the square of the golden ratio) of sky to sea can be very attractive depending on how it is used.

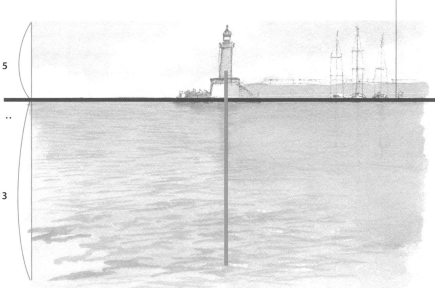

first line
horizon (sea level)

5

13

Compositions Divided at a Low Position (13:5)

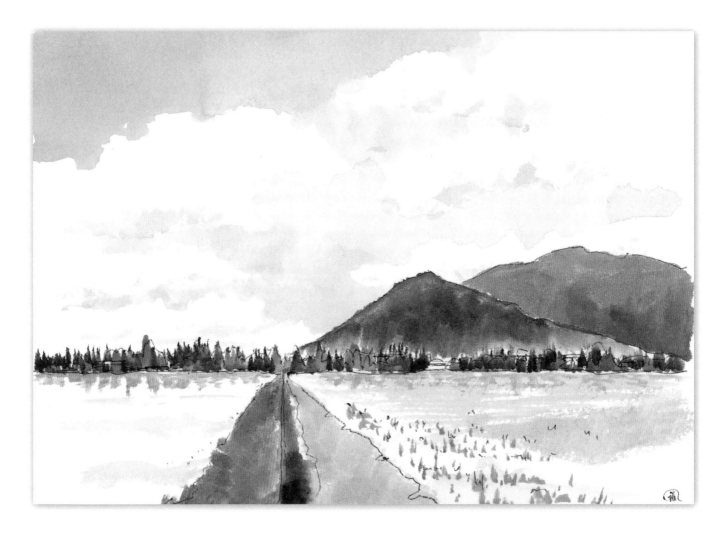

By reversing 5:13 on the vertical to become 13:5, a composition is created in which the ground and sky are divided at a very low position, thus creating depth.

In this example of a farming village with rice fields, the inclusion of the ridge of earth between the rice fields also expresses depth.

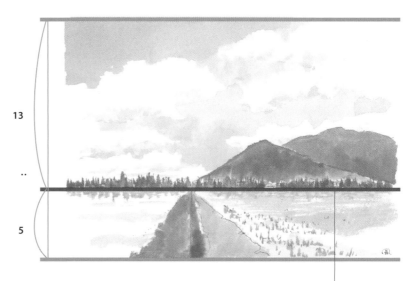

13

..

5

first line
horizon

Sketch Line Order

1 Rough positioning

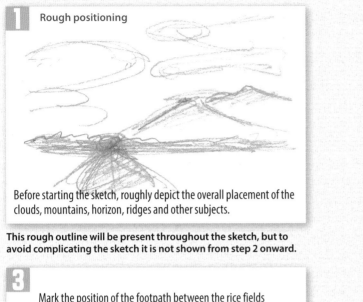

Before starting the sketch, roughly depict the overall placement of the clouds, mountains, horizon, ridges and other subjects.

This rough outline will be present throughout the sketch, but to avoid complicating the sketch it is not shown from step 2 onward.

2 Start

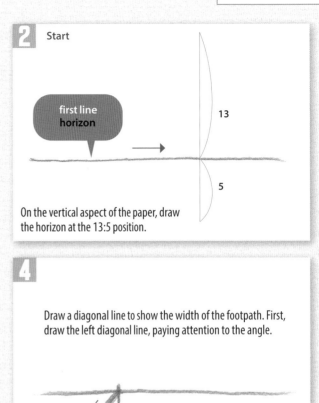

On the vertical aspect of the paper, draw the horizon at the 13:5 position.

3

Mark the position of the footpath between the rice fields using a straight line.

4

Draw a diagonal line to show the width of the footpath. First, draw the left diagonal line, paying attention to the angle.

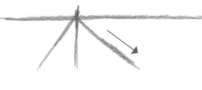

5

Next, draw the diagonal line on the right.

6

Sketch the frontmost triangular mountain, visible on the right.

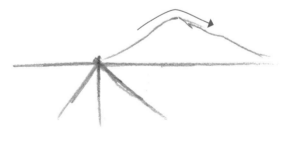

7

Draw the ridge line of the mountain in the background.

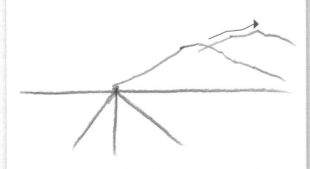

8

Add any other elements that should be sketched, for example, prominent buildings in the village.

Special Compositions from a Low Position

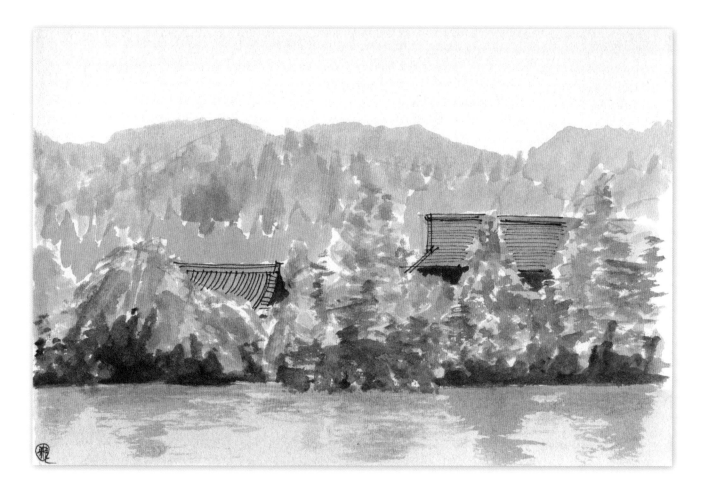

When depicting landscapes, part of the ground or water may be incorporated into the picture. The reason for this is to convey a sense of the location of the scene.

In this picture, for example, the main feature is the way the temple buildings are peeking out from among the trees while the trees are reflected in the pond in the foreground. The pond expands the scope of the piece even if it is only a small part of the whole picture.

In this drawing, the ratio of the greenery and sky above to the area of the pond below is 21:5. This is equivalent to the cube of the golden ratio and the ratio of 1.

21

5

first line
horizon

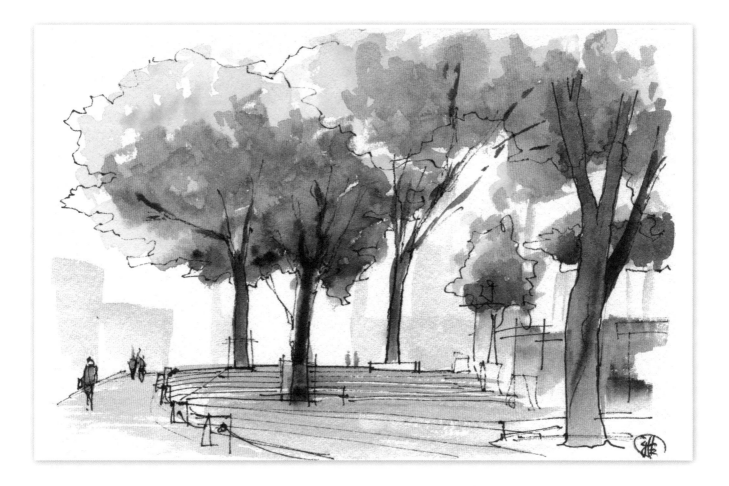

This picture is not as precise as the one on the left, but it is close to a ratio of 21:5. Even though the ground is only a small percentage of the whole picture, it plays an important role.

In the city center's small park, the steps between the trees form curved terraces, creating a stylish composition. While the ratio of ground and sky cannot be easily shown in a unified way, it has a ratio close to 21:5, revealing that even the smallest section of a picture can have significance in its division.

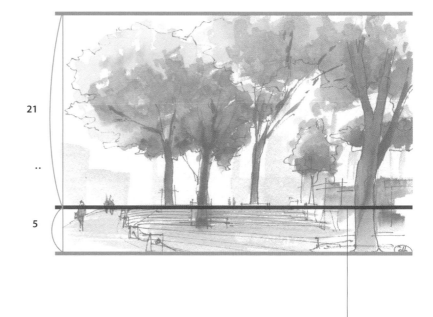

21

..

5

first line
horizon

CHAPTER 4

Expressing Depth in One Direction

In this chapter, I explained a technique that is simple for beginners of sketching to understand and makes it easy to create attractive drawings. Even though the technique does not use complicated perspective, it can still express depth. However, as there is depth in one direction only, there is a single point in the far distance where all the parallel elements converge. The diagonal lines leading to that point should be sketched as straight, solid lines. If the angles of the diagonal lines are not perfect, the image's perspective and spatial depth will be adversely affected. From experience, if the slant (angle) is off by around two degrees when measured with a protractor, it will drastically change the character of the picture. It is best not to use a ruler to measure the slant, but it is important to pay close attention to the angle of the diagonal line. Because they are important, these diagonal lines are usually drawn in the early stages of the sketch.

Those new to sketching may often place familiar objects on a table and start drawing them. With this kind of subject, the symmetry and harmony created through the placement of the objects becomes the theme of the picture. Since the emphasis is on the relationship between the arranged objects, there is no need to pay attention to creating a sense of depth, or more particularly, spatiality. Presuming those are the composition and sketching skills that have been learned, it will be challenging at first to incorporate an expression of depth. That said, we encounter a wide range of landscapes while outdoors or traveling, whether they are townscapes or splendid natural scenery, and this makes us keenly aware of the sense of distance and difference in height. To draw this kind of subject, you first need to learn how to express depth in one direction. The position of the point of convergence and the diagonal lines leading to it are drawn first, and the way these lines are drawn determines the composition.

Depicting a Building Facade and Creating Depth with the Foreground

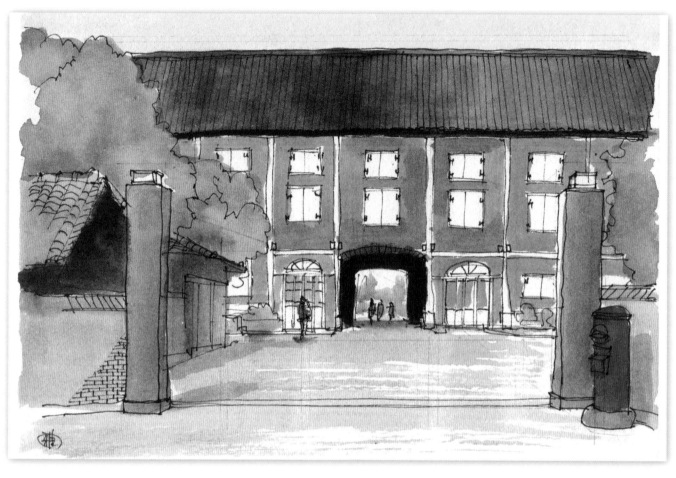

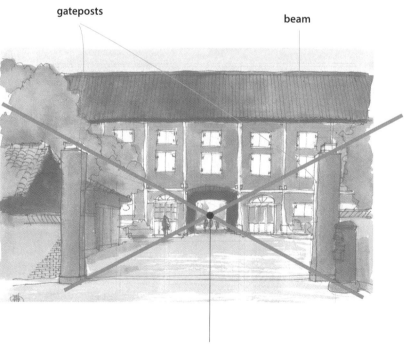

gateposts

beam

first point
point of convergence

This is a view from the front entrance looking toward the main factory of the Tomioka Silk Mill, a World Heritage Site located in Gunma Prefecture in Japan. For this subject, I will give an explanation of a composition that depicts a building viewed from the front.

In this case, the point is depicted in the foreground. There are two gateposts. Pay attention to the three-dimensional expression of these gateposts. It is important to clearly depict the diagonal lines so that the top and bottom lines of the sides of the gateposts meet at a single point in the far distance.

Sketch Line Order

1 Rough positioning

Before starting the sketch, roughly mark the overall layout and composition, including the positions of the gateposts, size of the roof and wall, etc.

This rough outline will be present throughout the sketch, but to avoid complicating the sketch it is not shown from step 2 onward.

2 Start

first line
point of convergence

Set the first point. This corresponds to the point of convergence (also known as the vanishing point) in a perspective drawing.

3

Draw diagonal auxiliary lines from the point of convergence and sketch the two gateposts in the foreground. Start with the front side.

4

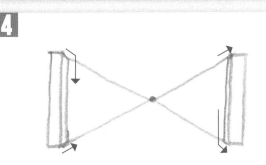

Sketch the shape of the sides of the gateposts. Draw four short lines toward the point of convergence, making sure to capture the angle.

These can be drawn in any order.

5

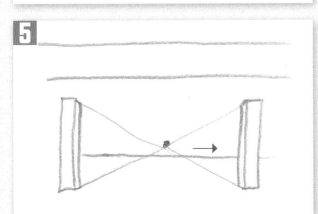

Add the positions of the roof and the front wall of the factory.

6

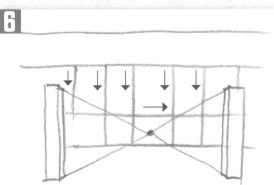

Mark the position of the columns that create an accent on the factory's exterior wall. Then, add the horizontal beam.

7

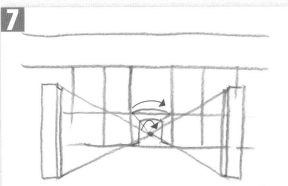

The walkway extends all the way from the main gate. Where it forms a passageway through the building is important, so it should be sketched to reflect the depth of the building.

8

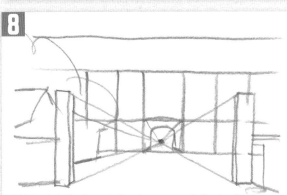

Add simple indications of other elements needed in the sketch.

It is a good idea to sketch auxiliary lines to show the position and shape of the openings in the exterior wall, but don't overdo it.

Depicting a Facade Viewed Slightly from the Side

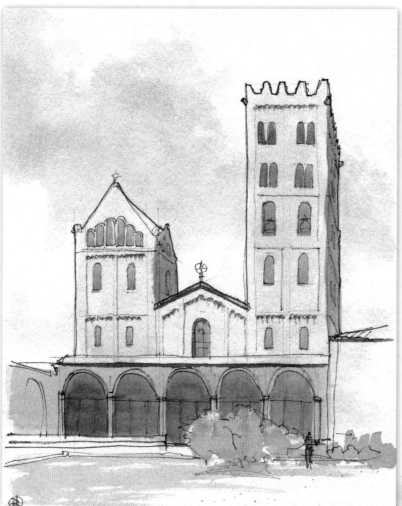

Drawing a building slightly from the left or from the right rather than directly face-on will create a much greater sense of depth.

Here, you can see the side of the building, even if only slightly. But the presence of that wall is significant. In this composition, first try to depict only the front wall rather than depicting both the front and side at the same time. This means that there is not much difference to the order of drawing when standing directly facing the facade. It is best to sketch the two towers as two rectangles.

first line

step 8
diagonal line
(orange)

point of
convergence

Sketch Line Order

1 Rough positioning

Before starting the sketch, roughly mark the overall layout and composition. If you do not do this, you may run out of space on the paper while drawing.

This rough outline will be present throughout the sketch, but to avoid complicating the sketch it is not shown from step 2 onward.

2 Start

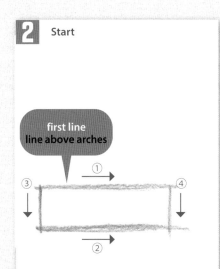

> first line
> line above arches

First, focus on the five arches at the entrance on the first floor. The arches themselves will be sketched much later, so to begin draw the rectangle while checking the aspect ratio.

3

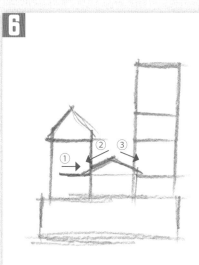

Sketch the taller tower on the right. Draw this as a rectangle, again while checking the aspect ratio.

4

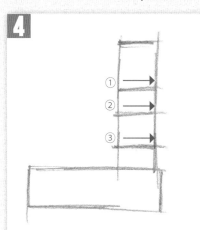

Add the horizontal division lines corresponding to each floor. This will make steps 5 and 6 easier.

5

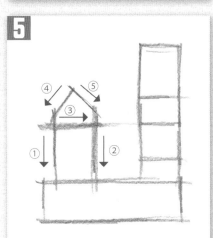

Draw the left tower. Sketch the triangular shape at the top at the same time.

6

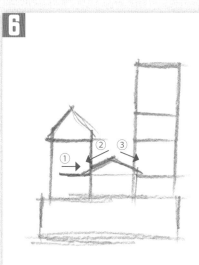

Sketch the triangular roof between the two towers.

7

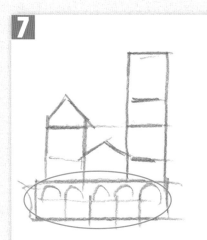

Sketch the appearance of the arches on the exterior of the first floor.

Up to here, no aspects related to the sense of depth have been drawn, but that is fine.

8

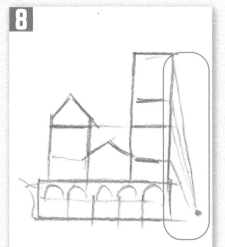

Position a point of convergence on the right and draw several important diagonal lines from the side wall toward that point.

9

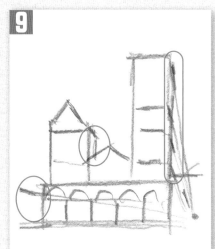

Add the sides of the towers, etc.

A Waterway Extending to the Right

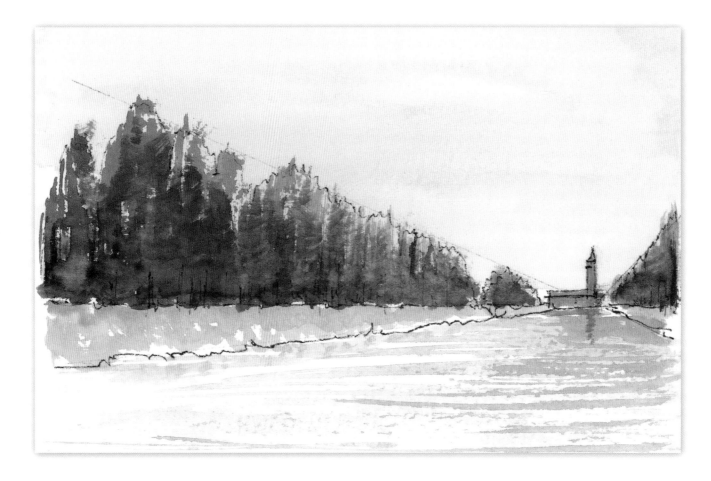

Canals stretch in all directions across the lowlands of Europe. Although this is a simple composition, it creates a strong sense of distance. As explained on the next page in the Sketch Line Order, every line plays a specific role. It is particularly important to depict the correct angles for the diagonal lines.

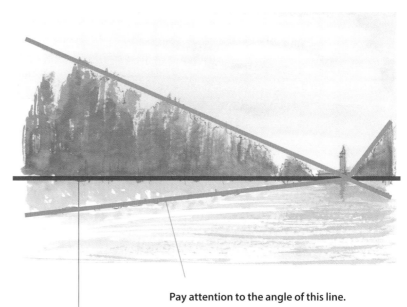

Pay attention to the angle of this line.

first line

Sketch Line Order

1 Rough positioning

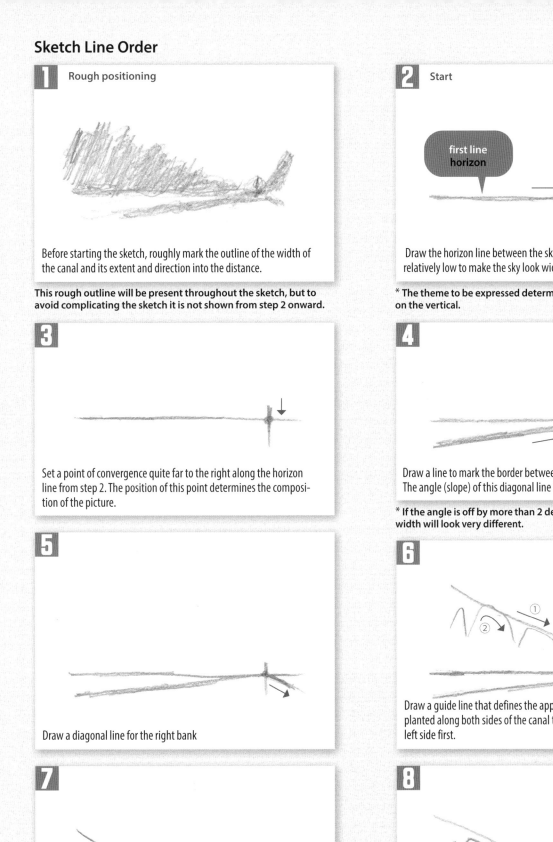

Before starting the sketch, roughly mark the outline of the width of the canal and its extent and direction into the distance.

This rough outline will be present throughout the sketch, but to avoid complicating the sketch it is not shown from step 2 onward.

2 Start

first line
horizon

Draw the horizon line between the sky and the ground. Position it relatively low to make the sky look wider.*

*** The theme to be expressed determines where this line will be set on the vertical.**

3

Set a point of convergence quite far to the right along the horizon line from step 2. The position of this point determines the composition of the picture.

4

Draw a line to mark the border between the water and the left bank. The angle (slope) of this diagonal line is very important.*

*** If the angle is off by more than 2 degrees, the image of the canal width will look very different.**

5

Draw a diagonal line for the right bank

6

Draw a guide line that defines the approximate height of the trees planted along both sides of the canal to provide windbreaks. Sketch the left side first.

7

Sketch the right side. The diagonal line has a very steep angle.

8

A church building can be seen in the far distance at the point of convergence. It is fine to express it as a simple outline at this point.

A Castle Tower with a Moat

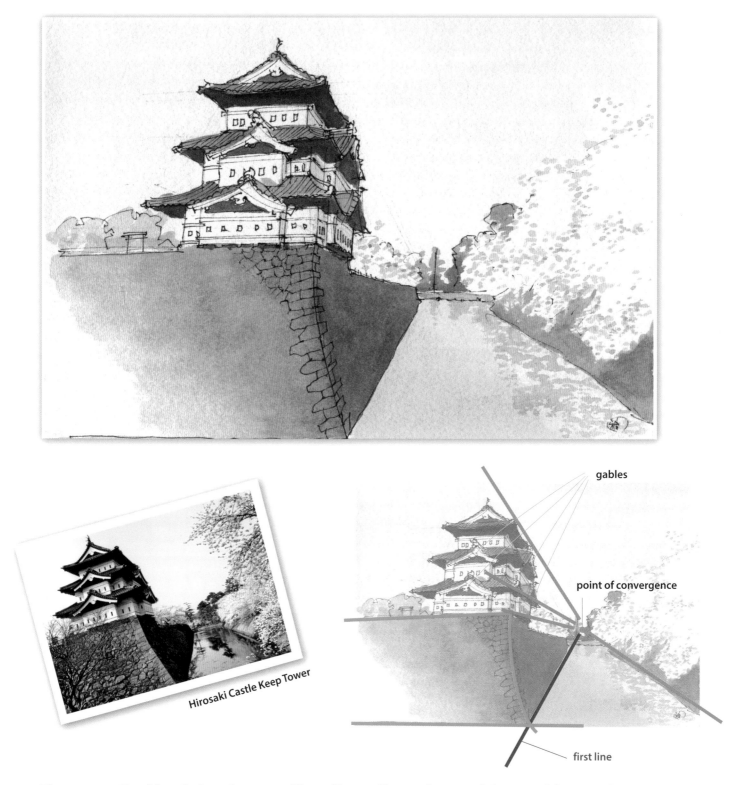

Hirosaki Castle Keep Tower

gables

point of convergence

first line

The outer walls of fortified castle towers ("keeps"), usually recede toward the top. If drawing from a position where two or more wall faces are visible, the walls will recede on each side, and it can be quite difficult to accurately express the three-dimensional shape. As shown here, if you draw it looking almost face-on at the facade, it will look like a keep tower. If you draw it together with the moat, it will a create a clear sense of depth. The keep tower sits on a stone wall base. You should draw the position of the point of convergence for the base and the shape of the stone wall before drawing the tower.

Sketch Line Order

1 Rough positioning

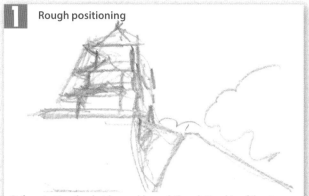

Before starting the sketch, roughly mark the relationship of the size and positioning of the stone wall, moat and keep tower.

This rough outline will be present throughout the sketch, but to avoid complicating the sketch it is not shown from step 2 onward.

2 Start

Assuming that the moat continues all the way into the distance, depict the water in the moat as a triangle. Set the position of the point of convergence in the first step.*

first line
moat line

*** The point of convergence is where the lines meet in the far distance. This point cannot be moved later.**

3

Draw the curve of the corner of the left wall. Show where the moat is cut off (turns a corner) in the distance.

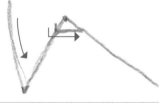

4

Draw the upper edge of the stone wall extending into the distance.

5

On the same stone wall, draw lines to mark the border of the moat and the upper front part of the wall.

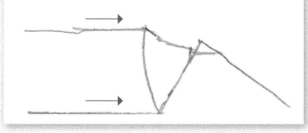

6

The stone wall forms the base of the castle keep tower. Sketch the tiers of roofs at the front of the tower, keeping in mind their relationship with the point of convergence.

7

Roughly draw the gables and other features of the keep tower.

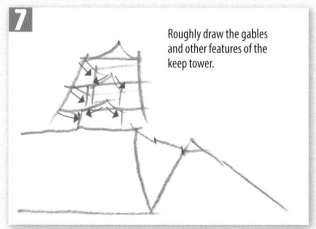

8

Sketch important shapes like the gables on the sides of the tower. Roughly draw the outlines of the clusters of surrounding trees.

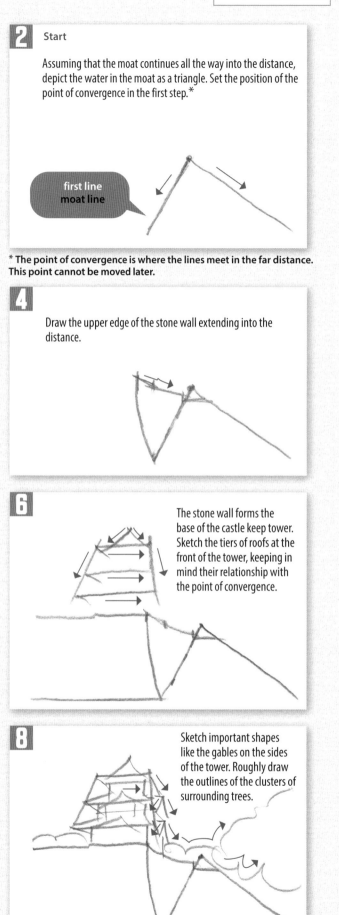

These can be drawn in any order.

A Gently Curving Waterway in the Snow

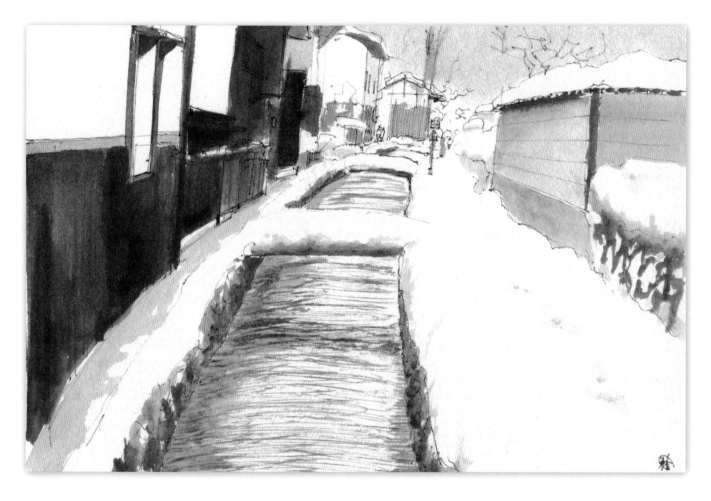

The points of convergence align horizontally.

first line
one point of convergence

The curve into the distance meets at a different point.

Here, we will draw a landscape depicting a town with storehouses and a river running through it in the Hida region of Japan. It is more accurate to call the river an irrigation channel. If this waterway was straight, it could be drawn using the technique mentioned earlier of setting one point of convergence in the far distance. Here I shall explain what needs to be done when the waterway curves, as in this example.

What is key with the multiple points of convergence is that they always align on the horizon line and that the points of convergence meet at different places.

Sketch Line Order

1 Rough positioning

Roughly sketch how the waterway curves, the stone bridges along the way and the size of the buildings on each side.

This rough outline will be present throughout the sketch, but to avoid complicating the sketch it is not shown from step 2 onward.

2 Start

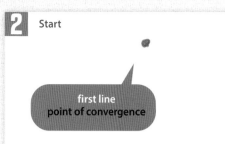

first line
point of convergence

Assuming for the moment that the waterway runs straight, add a point where all the lines would converge in the far distance.

3

Draw diagonal lines from that point, keeping in mind the width of the waterway.

4

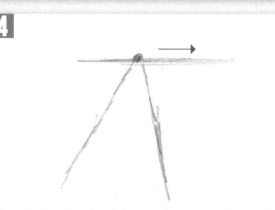

Draw a horizontal line through the point of convergence. This step is key.

5

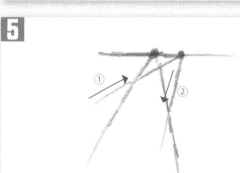

Look at how the waterway curves and determine its direction slightly further ahead. There are two points. While both are points of convergence, they are also both located on the horizontal line.

6

Draw the curve of the waterway and the stone bridges.

7

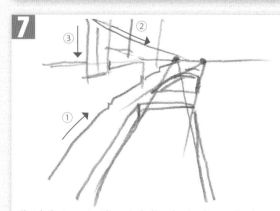

Sketch the important lines, including the storehouses lined up along the left.

8

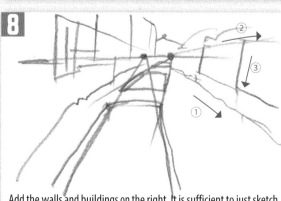

Add the walls and buildings on the right. It is sufficient to just sketch the position of the main buildings, but you can add more details if you like.

A Zen Garden

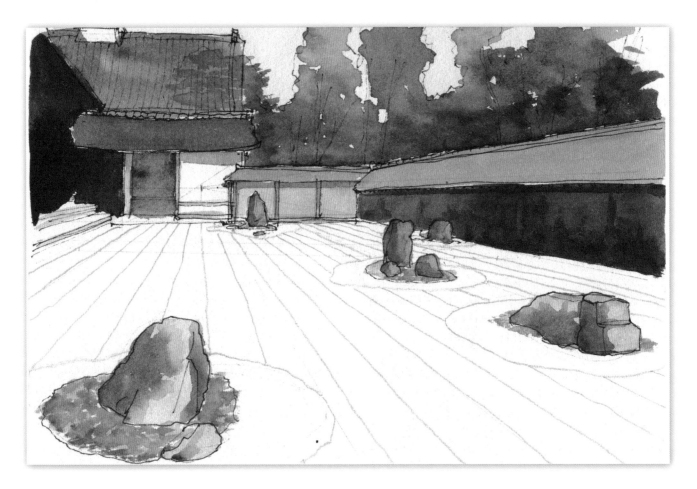

This is the famous Zen garden at Ryoan Temple in Kyoto. It is a simple garden comprised only of rocks surrounded by patches of moss and raked white gravel. Let us try drawing a composition where the parallel stripes of the walls and gravel in the Zen garden converge at a single point in the far distance.

The elements that can be placed in the landscape of a Japanese Zen garden are very limited, so a direct sense of depth is already conveyed. To explain it another way, while several sketch lines are drawn at the start, the subtle difference in their direction and angle will affect the overall effect of the drawing. For the rock in the foreground at left, think carefully about the balance and where it should be positioned.

first point
point of convergence

5 13

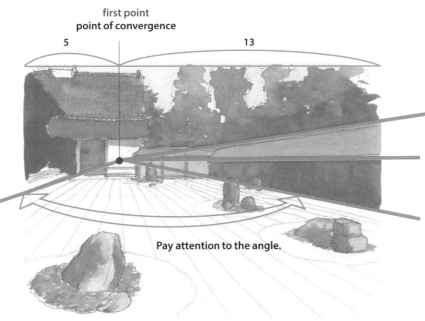

Pay attention to the angle.

Note: In this composition, the point of convergence is approximately 5:13 on the horizontal axis of the paper. This division is the square of the golden ratio (see pages 34–35).

Sketch Line Order

→ Line direction

1 Rough positioning

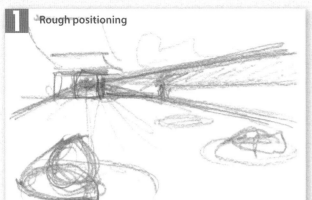

Roughly sketch the position of the elements and their relationship to each other. Use faint lines for these.

This rough outline will be present throughout the sketch, but to avoid complicating the sketch it is not shown from step 2 onward.

2 Start

first line
point of convergence

Because the parallel elements converge in the far distance, set the point of convergence to the left of center on the paper.

3

Determine the area of white sand. Start with the left edge. Carefully choose the angle and draw.

4

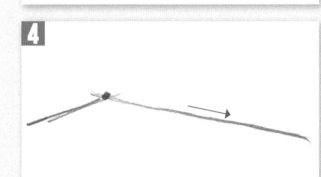

Draw the diagonal line of the right edge. It will run along the edge of the wall.

5

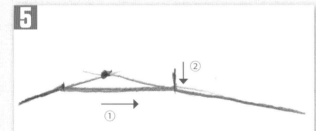

①
②

Determine the position of the front-facing wall at the far end of the garden. The two diagonal lines from steps 3 and 4 and the horizontal line here in step 5 determine the size of the rock garden. These are the most important lines, which should be drawn first.

6

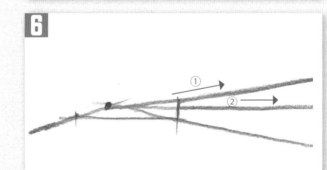

①
②

Sketch the wall and surrounding buildings, as well as the rocks in the garden. Add the mud walls and roof.

7

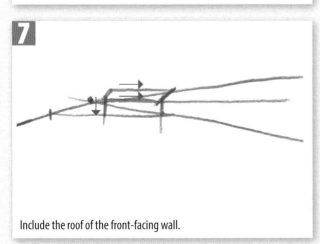

Include the roof of the front-facing wall.

The lines with no numbers can be drawn in any order.

8

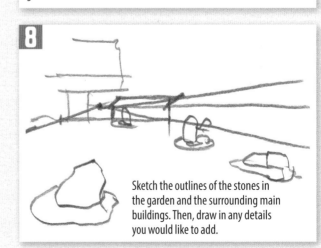

Sketch the outlines of the stones in the garden and the surrounding main buildings. Then, draw in any details you would like to add.

Downtown Buildings

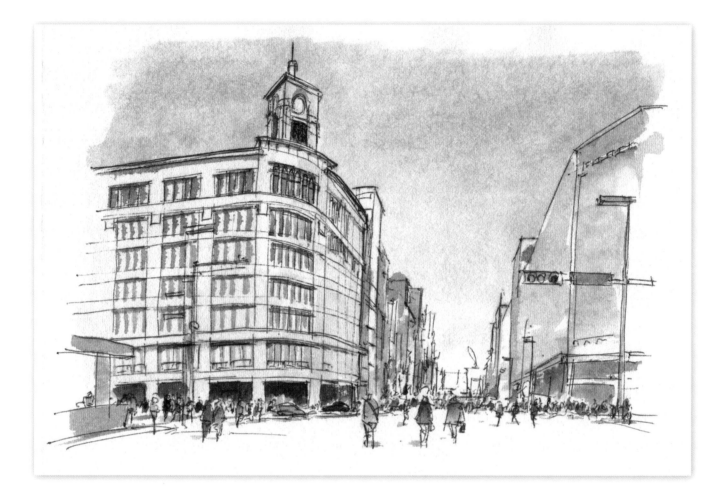

When drawing a commercial building, the method I use is to draw it together with a bustling street. A second method is to highlight the building and not draw much else around it.

The second method is connected with the three-dimensional expression of buildings, which I explain in Chapter 5. The first method is described here, and it uses the sense of depth to best effect in order to depict a downtown atmosphere.

This picture is a cityscape depicting the busy Nissan Crossing in Ginza, Tokyo. The view extends into the far distance along the main street. That forms a single point of convergence. The buildings on both sides are drawn as a composition with the sides of the buildings extending in the direction of that single point of convergence.

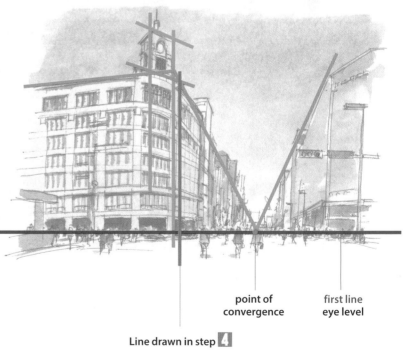

point of convergence

first line eye level

Line drawn in step 4

Sketch Line Order

1 **Rough positioning**

Roughly sketch the size of the building and its positional relationship to the main street.

This rough outline will be present throughout the sketch, but to avoid complicating the sketch it is not shown from step 2 onward.

2 Start

Draw a horizontal line at the eye level of the people in the street. This is necessary in order to draw the tall buildings.

first line
horizon at eye level

3 Set a point of convergence one-third of the way from the right on the horizon line drawn in step 2.

4 For the building on the left, decide where the lines on the roof edge intersect with the two main exterior walls and draw a vertical line.

5 Set the height of the exterior walls on both sides of the line drawn in step 4.

6 Draw the exterior wall of the building on the right in the same way.

7 On the corner is a clock tower that appears to be angled at 45 degrees. Indicate that 45-degree shift here.

8

Add auxiliary lines to the building on the left to represent the number of floors. These can be drawn in any order.

Connected Arches

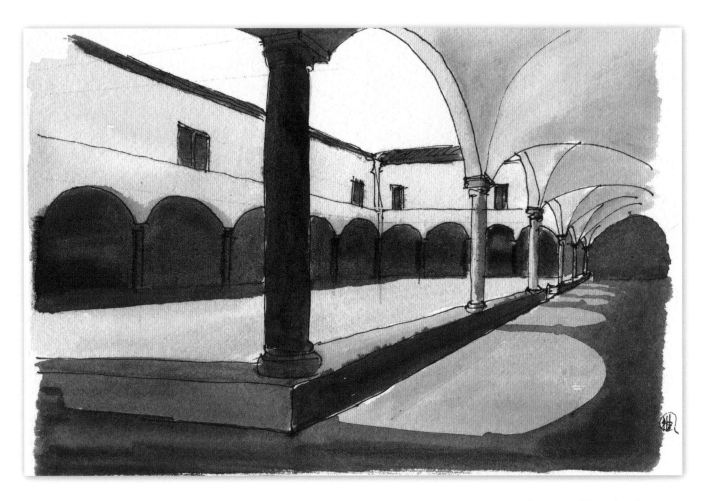

This is a space containing a series of arches often seen in the courtyards of Western European monasteries and churches. It is a fun project, although it requires a certain amount of skill to draw the spacing between the columns and to accurately express the depth of the arches, and so it may be daunting to beginners. Much depends on the level of expression you want to create.

The way the columns are neatly lined up is similar to the rows of notes in a musical score. Do not draw the arches right away. Instead, sketch the spacing and positions of the columns using the center lines of the column shafts.

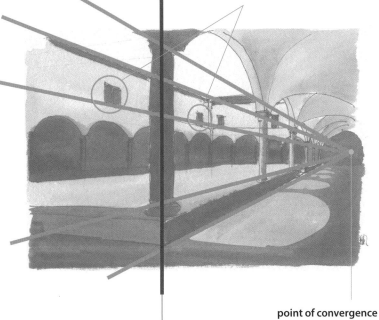

Be aware of the point of convergence when drawing the windows.

point of convergence

first line

Sketch Line Order

1 Rough positioning

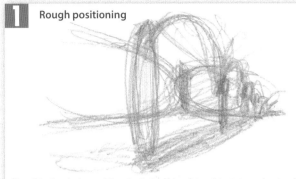

Roughly sketch the positional relationship of the objects to understand the size of the courtyard and the rhythm of the rows of arches.

This rough outline will be present throughout the sketch, but to avoid complicating the sketch it is not shown from step 2 onward.

2 Start

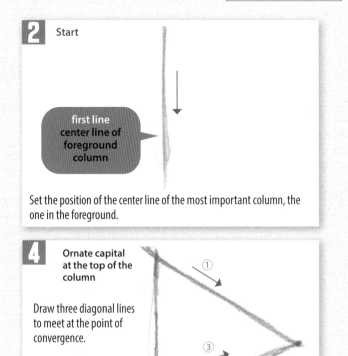

first line
center line of
foreground
column

Set the position of the center line of the most important column, the one in the foreground.

3

Point of
convergence

Determine the point where the rows of columns come together in the far distance.

4 Ornate capital
at the top of the
column

Draw three diagonal lines to meet at the point of convergence.

① ③ ②

Column base

Side of the stylobate base under the column

From top to bottom: The position of the column's capital; the position of the pedestal; and the position of the foundation that supports the column.

5

① ② ③

Draw the center lines (cores) of the columns from left to right.

6

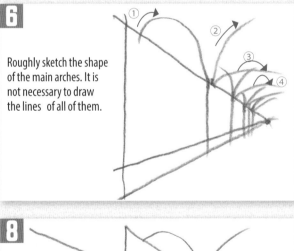

① ② ③ ④

Roughly sketch the shape of the main arches. It is not necessary to draw the lines of all of them.

7

Define the farthest wall that faces the courtyard. Draw the low stylobate platform so that it runs under the bases of the columns, thus connecting them.

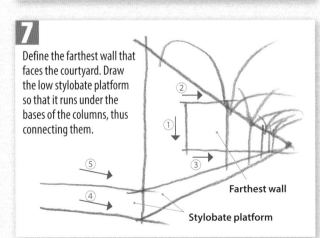

② ① ③ ⑤ ④

Farthest wall

Stylobate platform

8

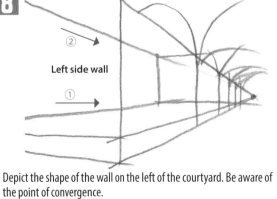

② ①

Left side wall

Depict the shape of the wall on the left of the courtyard. Be aware of the point of convergence.

To complete the underdrawing, add auxiliary lines to define column widths, arches, alcoves and doorways, etc.

A Garden Extending Into the Distance

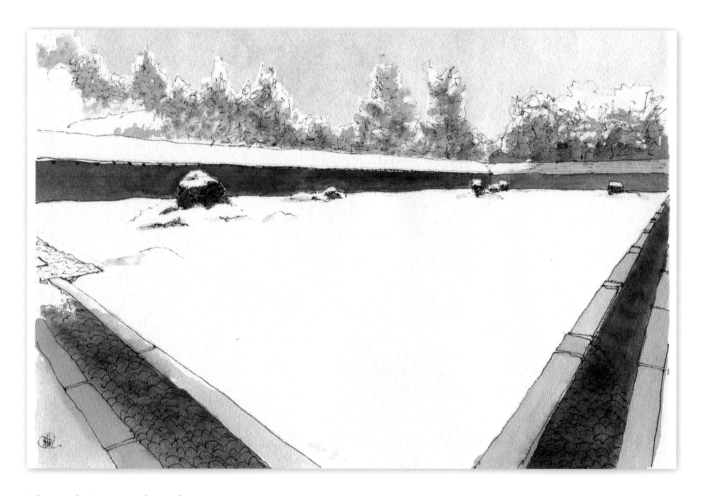

This is the Zen garden of the Ryoan Temple in Kyoto covered in snow. In this type of landscape, where four walls enclose the space, the garden can be made to appear as wide as possible depending on the composition. This effect is usually achieved by using two points of convergence, one on the left and one on the right, to create two points of perspective. However, this differs from the effect with a three-dimensional object like a building. When applied to a garden, it can be used to emphasize more space than usual as it extends outward toward the background.

Deciding the position of this line is important.

point of convergence

first line

point of convergence

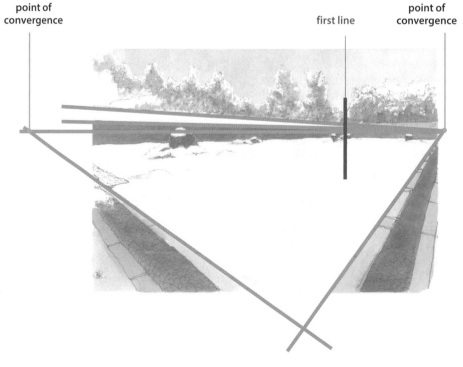

Sketch Line Order

1 Rough positioning

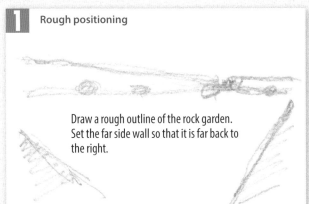

Draw a rough outline of the rock garden. Set the far side wall so that it is far back to the right.

This rough outline will be present throughout the sketch, but to avoid complicating the sketch it is not shown from step 2 onward.

2 Start

first line
wall border

Determine where the borders of the left and right walls meet at the far end of the four-walled enclosure and draw a line.

3

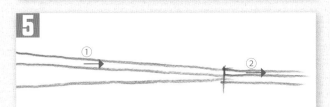

Draw the outline of the right wall, including the roof.

4

Draw the outline of the left wall. The straight lines here have a slight angle, so draw them carefully.

5

Draw lines for the roof eaves over the walls between the lines drawn in steps 3 and 4.

6

Draw a line for the curb of the rock garden in the foreground at right. Add lines to indicate the edges of the granite slabs and river stones.

7

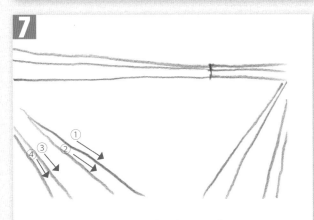

Add similar lines on the left side of the foreground.

8

Roughly draw the size and position of the groups of rocks. Then, outline the trees visible outside the walls.

Determining a 3D Expression with the First Two Directional Diagonal Lines

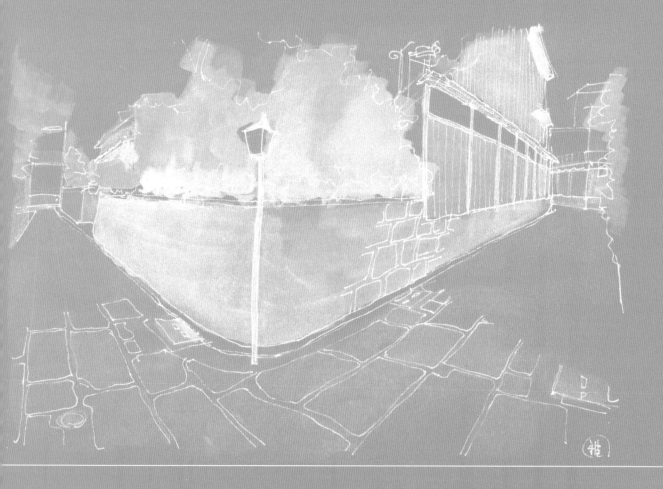

In the previous chapter, we focused on subjects where one point of convergence was used to convey a sense of depth. In this chapter, the focus is on subjects that have two points of convergence, one on the left and one on the right of the drawings, to also convey a sense of depth. The continuous lines running from both directions will intersect at the same position, or height, on the vertical axis of the paper, approximately in the center of the paper.

Take as an example a building where the corner is positioned midway between the left and right walls, and the lines extending from the two points of convergence meet along the corner. When drawing common subjects, the points of convergence on the left and right will generally intersect at the same position (height) on the vertical axis of the paper. That is why it is particularly important to draw vertical edges accurately in the early stages of the sketch. It is also important to remember that with only one point of convergence, it is easier to set that point on the paper. When the points increase to two, it becomes more difficult to draw both, so there will be cases where one or both of the points of convergence will extend beyond the edge of the paper. In fact, this is a common occurrence.

The most challenging scenario is where both points of convergence extend beyond the edges of the paper even though the diagonal sketch lines are drawn toward each point of convergence. This is what makes this chapter more challenging than the previous one. But as you become more familiar with the technique, you will learn which parts to omit in the first sketches.

When the Points of Convergence Extend Beyond the Edge of the Paper

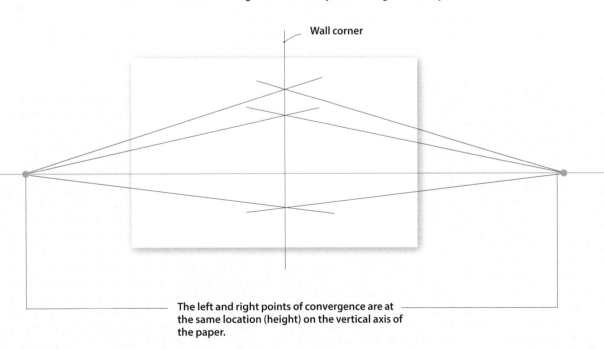

Wall corner

The left and right points of convergence are at the same location (height) on the vertical axis of the paper.

Buildings with No Visible Ground

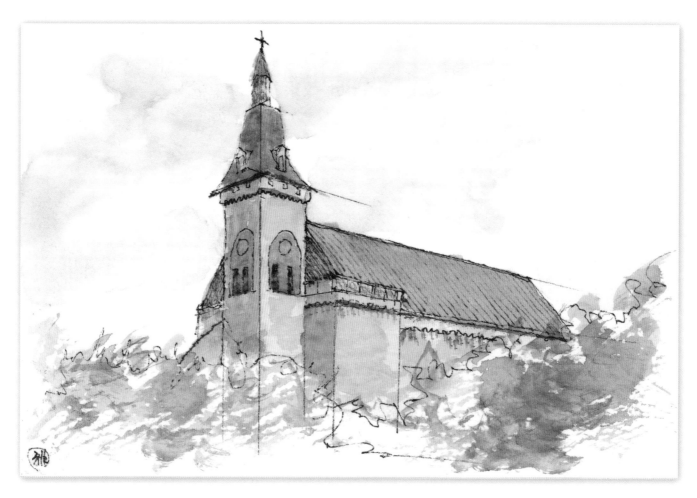

When drawing a building, if you can see where it is placed on the ground, you will get a much better idea of the size of the building and the angle of the view to be drawn, whether it is positioned on flat or sloped terrain. This makes it easier to draw three-dimensional shapes. In reality, most often the ground on which a building is placed cannot be seen or it is not possible to grasp the whole structure of the building because the view is blocked by other structures and objects.

In this drawing of a church with a tall tower and steeple, you will be viewing it from a distance. Elements of the walls that are normally horizontal will become diagonal, so pay attention to the angles while sketching those lines.

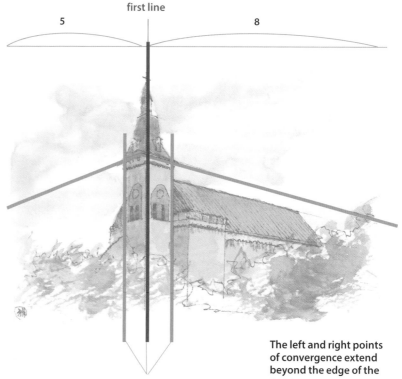

first line

5 8

Draw the three lines parallel.

The left and right points of convergence extend beyond the edge of the paper.

Sketch Line Order

1 Rough positioning

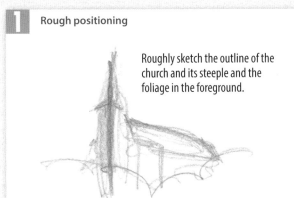

Roughly sketch the outline of the church and its steeple and the foliage in the foreground.

This rough outline will be present throughout the sketch, but to avoid complicating the sketch it is not shown from step 2 onward.

2 Start

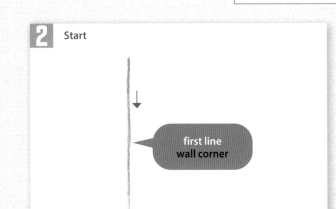

first line
wall corner

Draw a borderline between the left and right walls of the tower.

3

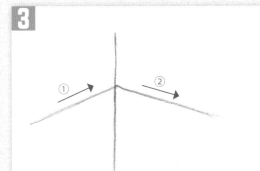

Carefully draw two diagonal lines on each side of the borderline. The vertical line above them indicates the height of the tower and steeple.

4

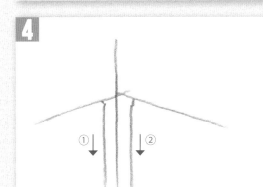

Draw two vertical lines to indicate the size of the walls on either side of the tower.

5

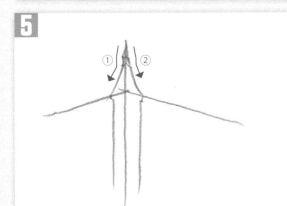

Sketch the curved roof of the tower with the steeple on top.

6

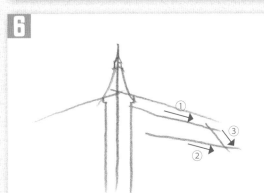

Draw lines to show the large roof of the church. One point of convergence extends beyond the edge of the paper on the right.

7

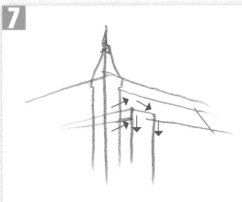

Sketch the shape of the protruding square wall on the right.

8

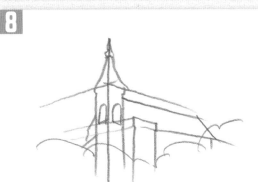

Sketch the other main outlines. The direction of the diagonal lines will differ depending on whether the wall faces left or right, so draw them separately but in any order. Also sketch the trees outside the walls.

Buildings with Colonnades

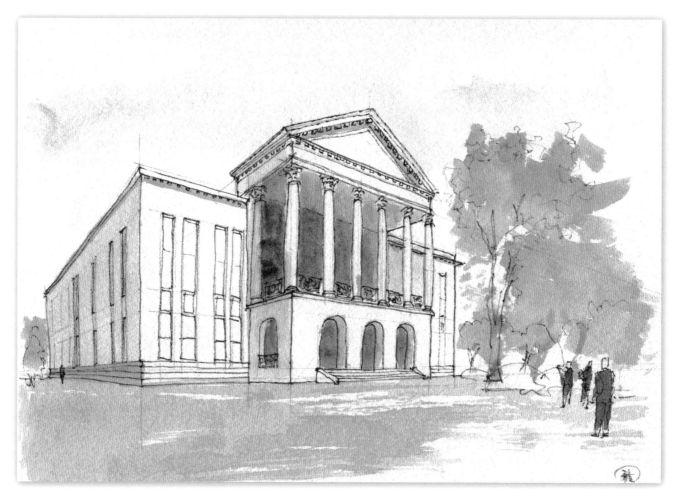

This is an auditorium on the campus of Aoyama Gakuin University in Shibuya, Japan that has an symmetrical exterior in the style of a Greek temple. In this picture, the auditorium is viewed from a position where both the front and the protruding side walls are visible.

There are points of convergence to the left and right in terms of perspective. However, in this picture, the one on the right extends beyond the edge of the paper, making it difficult to capture it in the picture.

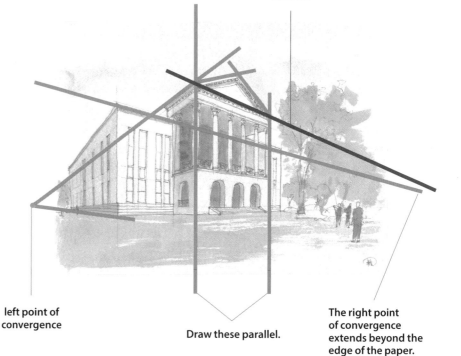

first line

left point of convergence

Draw these parallel.

The right point of convergence extends beyond the edge of the paper.

Sketch Line Order

1 Rough positioning

It is easier to sketch lines if you have a rough idea where to place the boundary between the front and side of the buildings. It is also important to have a good understanding of the overall size and shape of the building.

This rough outline will be present throughout the sketch, but to avoid complicating the sketch it is not shown from step 2 onward.

2 Start

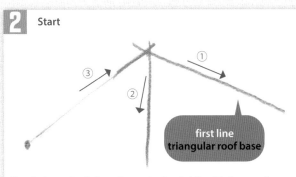

first line
triangular roof base

Sketch the section in front that protrudes slightly with the row of colonnades. For the base of the triangular roof, draw a corresponding line, paying attention to the angle.

3

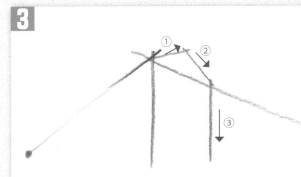

Add the front triangle and make the outline of the front protrusion clear.

4

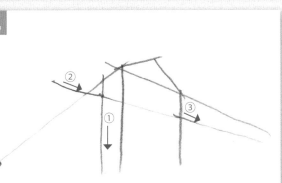

Taking into account the protruding section, determine the position of the front wall of the exterior lower part of the building.

5

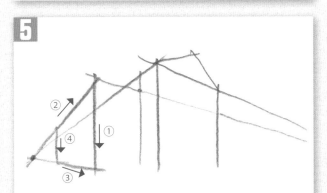

Sketch the exterior wall of the lower part of the building on the left.

6

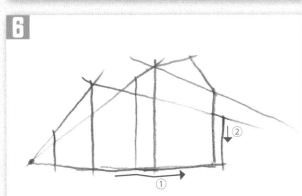

Sketch the section where the building and ground meet, and then add a line for the right edge of the building.

7

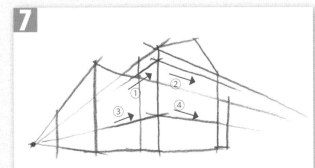

Decide on the positions of the horizontal beams and bases of the colonnades before drawing them.

8

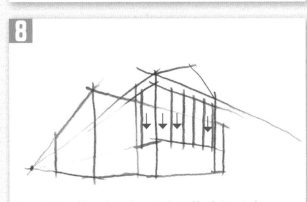

The positions of the colonnades are indicated by their centerlines, so sketch the required number of lines. Draw them in any order.

Traditional Japanese Architecture: A Temple Hall with Tiled Roof

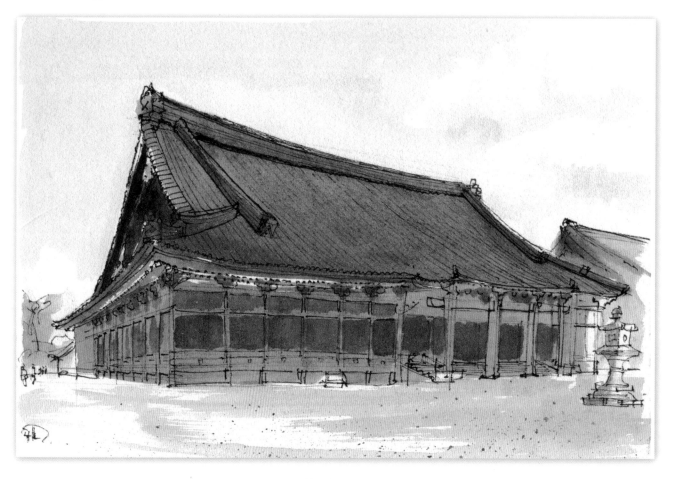

Here, we will try drawing the main hall of a temple in the city of Kyoto, viewing the facade from a slight angle. Traditional Japanese architecture is characterized by designs that include complex wooden structures. The tiled roof itself has a sense of weight to it, while the curves visible in the eaves and other parts add a delicate structural beauty. A high level of expression is needed, so I will explain the sketching process, focusing on how to depict the shape of the roof.

Depending on the subject, you may start with sketch lines like on the opposite page (**1**), but here, as with other sketches, you should create a rough draft first to get an idea of the shape and positioning of the building on the paper (**0**).

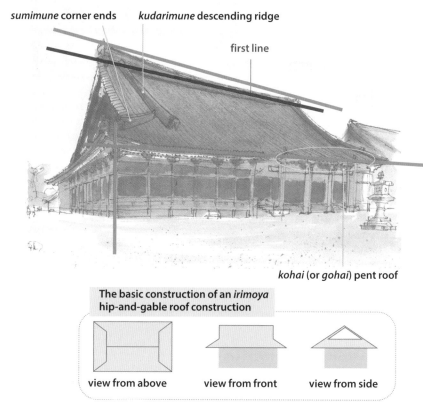

sumimune corner ends *kudarimune* descending ridge

first line

kohai (or *gohai*) pent roof

The basic construction of an *irimoya* hip-and-gable roof construction

view from above view from front view from side

Sketch Line Order

0 Rough positioning **Roughly sketch the overall size and shape of the temple hall.**

1

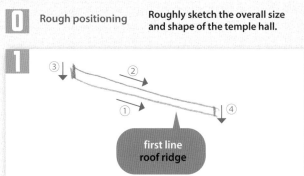

first line
roof ridge

Sketch the *mune* * or ridge of the roof. While it depends on the size of the building, the direction of this line is very important, so mark it carefully.

* The highest point at which the two sides of the roof meet.

2

Before drawing the outline of the roof, add the *kudarimune*, or descending ridge, in two places, on the left and right.

3

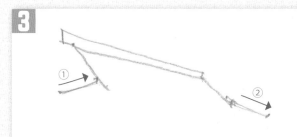

Add what is known as *sumimune*, or corner ends, which are ridges that appear to branch off partway.

4

Looking from front-on, draw the line of the eaves of the large roof. Do not draw the lines that depict the gentle curve of both sides yet. These will be blended in at step 5.

5

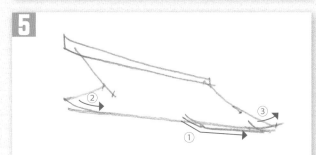

Add what is known as a *kohai*, or pent roof, the roof over the steps of a temple, and draw the curved edges of the large roof.

6

Point of convergence

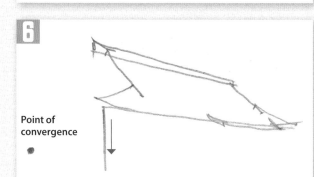

Add a line at the exact position of the boundary between the left and right exterior faces of the building. In addition, set the point of convergence at the left side of the building.

7

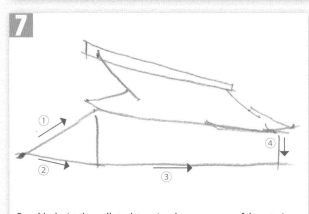

Roughly depict the walls to determine the appearance of the exterior.

8

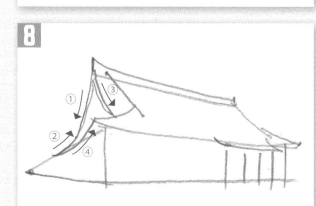

Draw a line to depict the side of the roof. This style is an *irimoya* hip-and-gable roof. What is key is to show the shape of the roof.

Traditional Japanese Architecture: An Entrance Gate

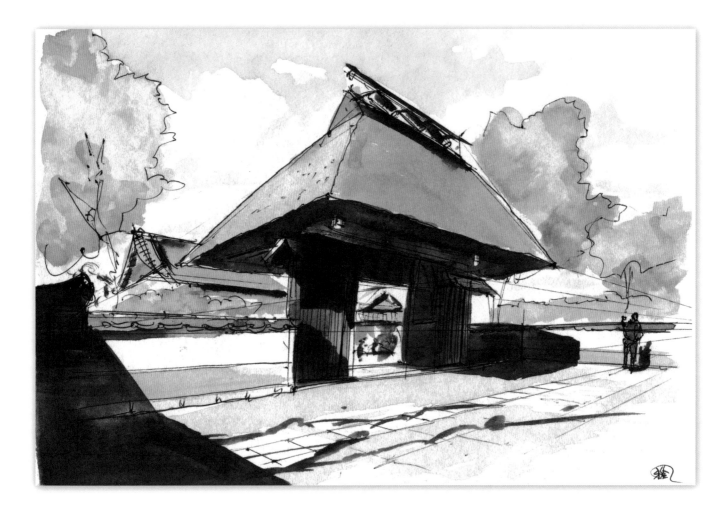

This is the same type of traditional architecture as shown on the previous pages, but here we will draw a gate with a thatched roof. The key point here is the expression of the roof. The quality of the first few lines will determine the whole image.

There are several ways to draw this, but here we will start with the line of the eaves at the front of the gate, and then proceed to clearly depict the area of the roof.

first line
The angle of this line for the eaves determines the final image.

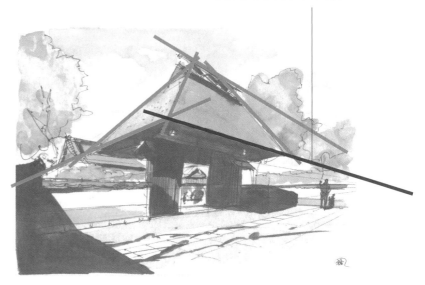

Sketch Line Order

0 Rough positioning **Roughly sketch the overall size and shape of the temple gate.**

1

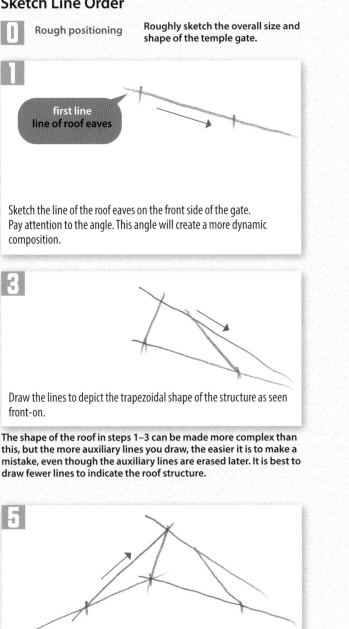

first line
line of roof eaves

Sketch the line of the roof eaves on the front side of the gate. Pay attention to the angle. This angle will create a more dynamic composition.

2

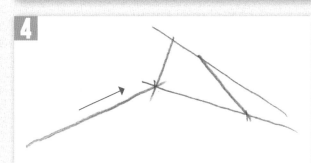

Draw a line from each end of the eaves to form the ridge lines of the roof.

3

Draw the lines to depict the trapezoidal shape of the structure as seen front-on.

The shape of the roof in steps 1–3 can be made more complex than this, but the more auxiliary lines you draw, the easier it is to make a mistake, even though the auxiliary lines are erased later. It is best to draw fewer lines to indicate the roof structure.

4

Start drawing the left side of the roof as seen from the front. First, sketch the line of the eaves.

5

Complete the side triangle.

6

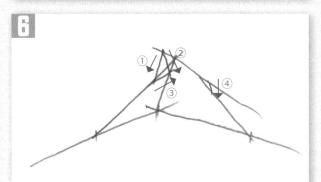

Neaten the shape of the ridge edge. The corners will protrude out and look more like a roof.

7

Sketch rough lines to connect the roof eaves. Keep in mind the image of a three-dimensional roof while doing this.

8

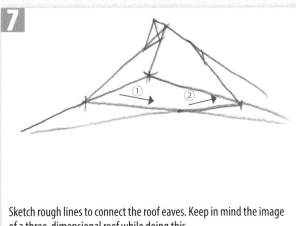
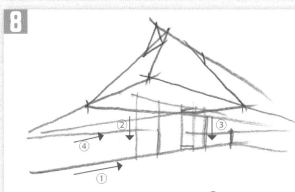

Draw the line that joins the gate with the ground ①, and then add important lines like the pillars that support the roof, as well as the doors and shape of the fence.

Buildings with Complex Depth

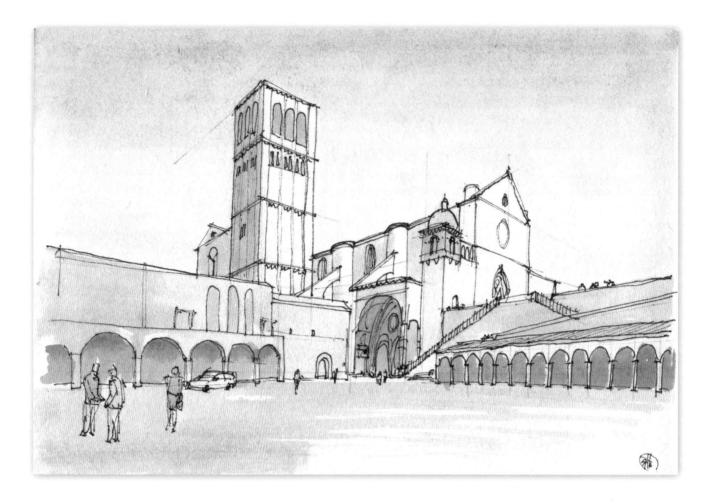

Anyone looking at this picture will want to try to draw it, as it shows an impressive complex with a broad plaza in front. The picture has a sense of scale with the tower, as well as rhythm with the continuous arches. The unevenness of the walls and their complexity enhance the charm of the scene.

This drawing falls into the difficult category. However, if you are able to carefully construct the main surfaces of a three-dimensional object, you will be able to draw this. To start the sketch, begin either with the tower or the facade of the church. Here, we will start drawing from the tower.

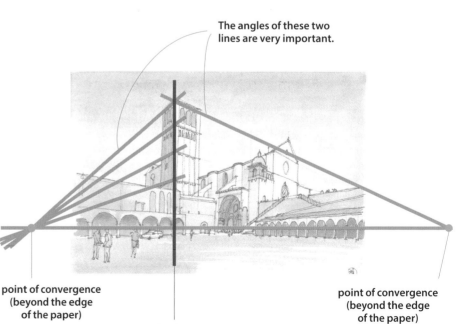

The angles of these two lines are very important.

point of convergence
(beyond the edge
of the paper)

point of convergence
(beyond the edge
of the paper)

first line

Sketch Line Order

0 Rough positioning **Roughly sketch the overall size and shape of the buildings.**

→ Line direction

1 Start

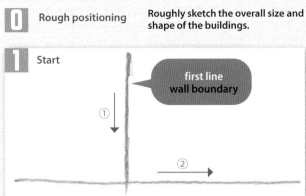

> first line
> wall boundary

Draw the boundary between the two walls of the tower, and then draw a horizontal line to indicate eye level.

2

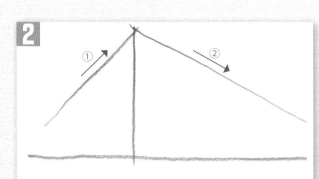

Draw two lines for the topmost part of the tower. The angle of these lines is very important.

3

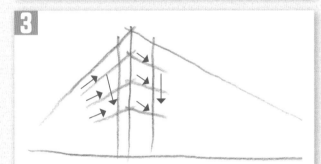

Draw the protruding parts that mark each level of the tower. These can be drawn in any order.

4

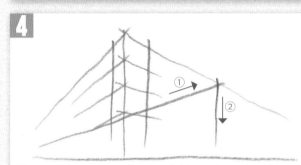

Move on to the main part of the cathedral. Draw a line running from the point of convergence beyond the edge of the paper on the left ① and add the boundary of the walls ②.

5

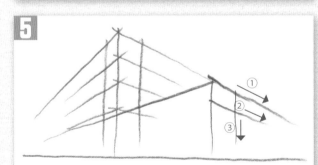

For the facade, draw a line toward the point of convergence on the right. Note that the point of convergence is beyond the edge of the paper on the right.

6

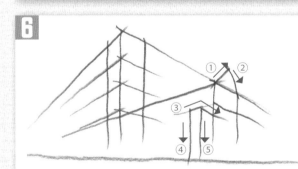

Add the triangle of the facade and draw the protruding section next to it.

7

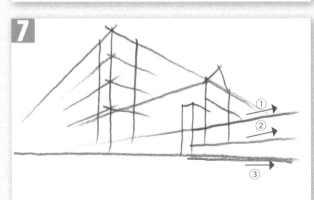

Using the line drawn in step 6 as a guide, determine on the position of the right wall facing the plaza.

8

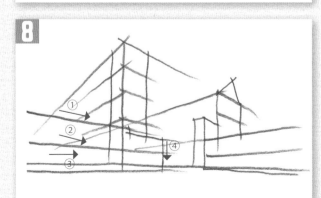

In the same way, sketch the size of the two-story building on the left facing the plaza. This completes the underdrawing of the basic structure.

A Fork in the Road

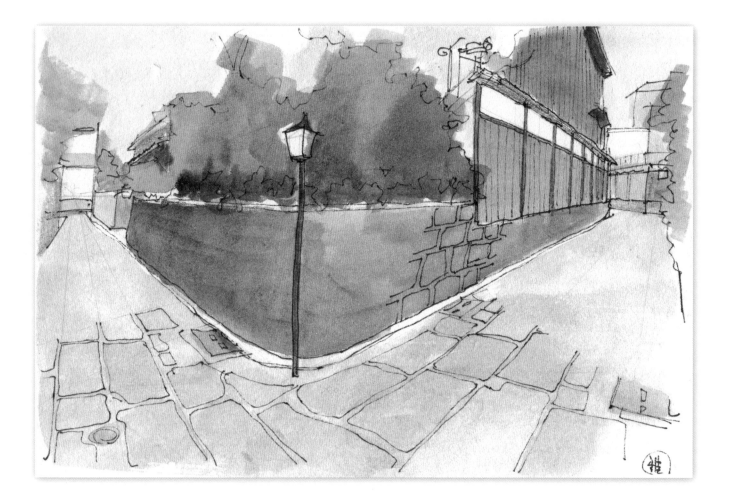

The scene of a road splitting in two directions is a popular motif for pictures. It is sometimes used as an example of a crossroads in life, but can also convey a variety of other meanings. For this theme, the two separate lanes lead directly away from the center of the picture, although it is not clear where they lead. This lends a sense of uncertainty for the future. At the same time, it makes us curious about what lies ahead.

Use the following sketches as a reference for how to express a sense of depth in two directions.

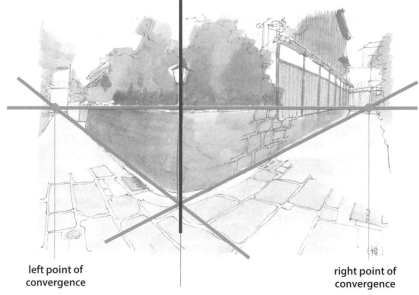

left point of convergence

first line

right point of convergence

Sketch Line Order

0 Rough positioning **Roughly sketch the main elements in the scene.**

1 Start

The stone wall straight ahead has a curved surface, but assuming that both walls are perpendicular to each other, draw a straight line at their boundary.

2

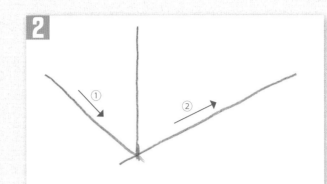

Draw diagonal lines from below the line from step 1 running to the left and right, defining the bottom of the wall.

3

Point of convergence

Set one point of convergence on the left. The point of convergence is always located on the horizon line.

4

Point of convergence

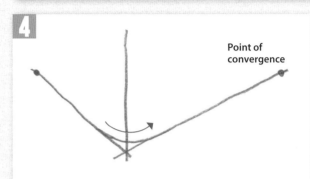

Set a second point of convergence to the right in the same way. Join the two lines so that they form a curve at the bottom of the wall.

5

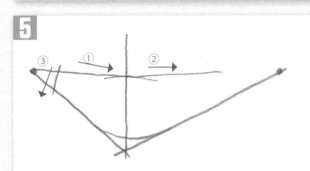

Draw a line marking the top edge of the stone wall. Make the height around eye level and almost horizontal. Continue by drawing in the position where the stone wall ends on the left.

6

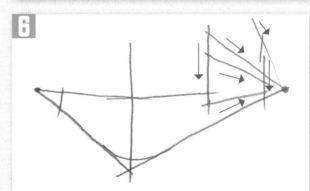

Add lines for the main eaves on the right and other parts of the wooden exterior walls of the house.

7

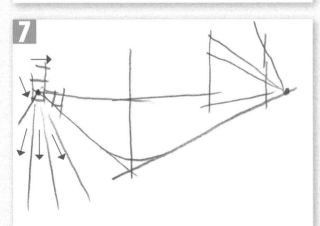

Faintly add slab lines in the stone pavement, starting with the left lane.

8

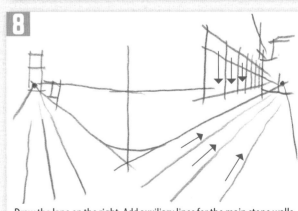

Draw the lane on the right. Add auxiliary lines for the main stone walls and buildings.

Expressing the Size of a Building

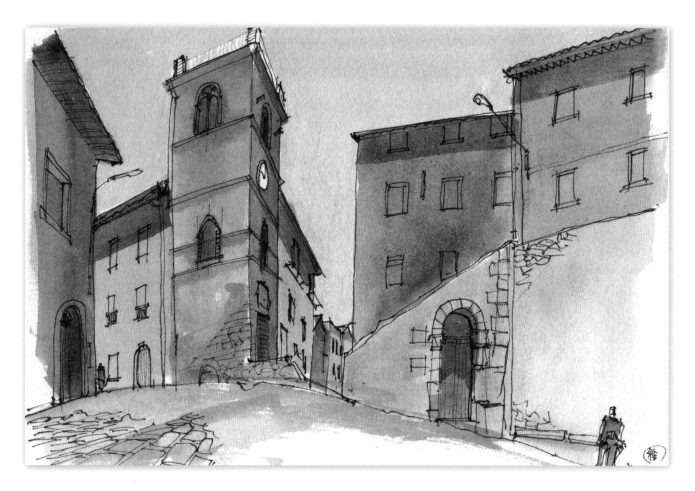

The historic townscapes of Western Europe are steeped in history. You can often come across picturesque scenes of medium-rise buildings lining winding alleys and streets. When drawing this kind of townscape, a key point to expressing the size and scale is to use window openings and the protruding levels of the buildings that indicate the number of floors they have. Drawing the appropriate shapes of windows can convey the size of the walls.

Another point is to always include the line of sight in the picture. If the line of sight falls below the edge of the paper, the composition will become one of a view looking up, which is explained in Chapter 6. Because the point of convergence for each building is always located on the line of sight, it means that eye level is very important.

point of
convergence (A)

left background
building's point of
convergence (B)

line of sight
(eye level)

first line

point of convergence (C)

Sketch Line Order



→ Line direction

0 Rough positioning — Roughly sketch the overall size and shape of the buildings in the street scene.

1 Start

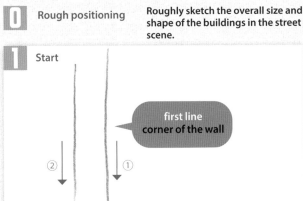

first line
corner of the wall

Decide on one typical wall that is easy to measure for size. Here, the tower-like building is best.

2

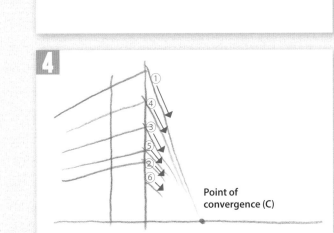

Draw a diagonal line, keeping in mind the point of convergence is located outside the edge of the paper. Decide on the position of the roof.

3

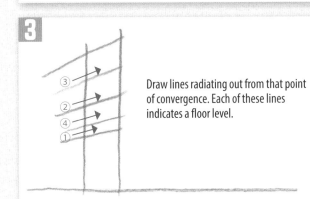

Draw lines radiating out from that point of convergence. Each of these lines indicates a floor level.

4

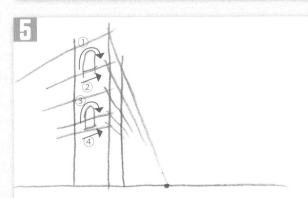

Point of convergence (C)

Describe the right side of the tower-like building in the same way.

5

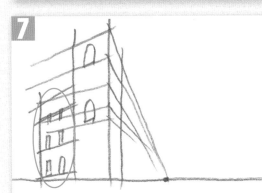

Sketch two windows, paying attention to the angle of the horizontal elements like window sills.

6

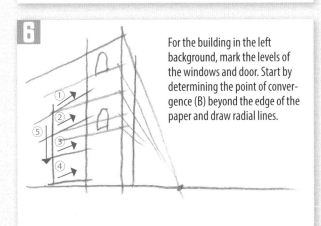

For the building in the left background, mark the levels of the windows and door. Start by determining the point of convergence (B) beyond the edge of the paper and draw radial lines.

7

Sketch the position of the windows. If buildings are lined up along a curved road, the point of convergence will often be different for each building.

8

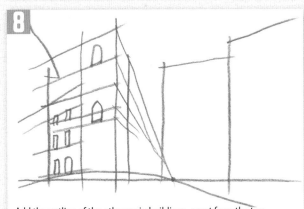

Add the outline of the other main buildings, apart from the two explained in the previous steps.

Determining a 3D Expression with the First Two Directional Diagonal Lines 87

The First Sketch Lines Determine the Look of a Landscape Viewed from Above or Below

In this chapter, I will explain how to sketch compositions that show either a view looking up or a view looking down. This can be quite a challenge for beginners. That is why in the first stage of sketching, it is important to get certain parts and their diagonal lines right.

In both sketches **A** and **B**, the angle is from the front, looking up at the same church. The two bell towers are the distinctive features of this building, so focus on them, but also be aware that the difference between them in the two pictures is a key point. In **B**, the two towers are more dramatically stretching toward the sky. The width of their walls gradually gets narrower as they go up, and they also gradually getting closer to each other as they rise. In general, objects drawn looking up seem to get closer together as they get higher. In **A**, the walls of the two towers have the same width at the top and the distance between them remains constant.

The main the difference between the two drawings is that in **B** the sky also has a point of convergence, while in **A** there is no point of convergence in the sky. When sketching for the first time, people tend to choose a composition like this, not realizing how difficult it is to understand the complexity of three-point perspective. With this composition, there is a point of convergence to each side and one in the sky as well, so you need to draw quite complicated lines. Thus, I recommend that beginners start by using the method in **A** to draw the picture.

A

Recommended

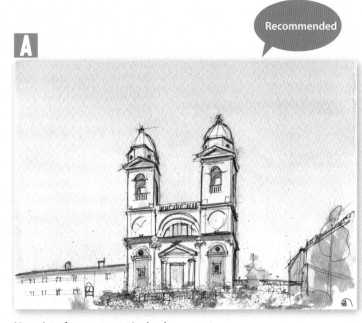

No point of convergence in the sky

B

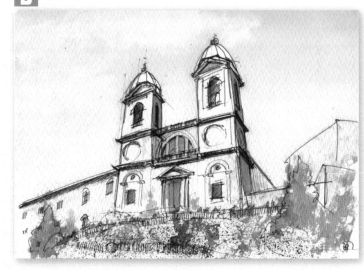

The sky also has a point of convergence

Looking up at a Facade

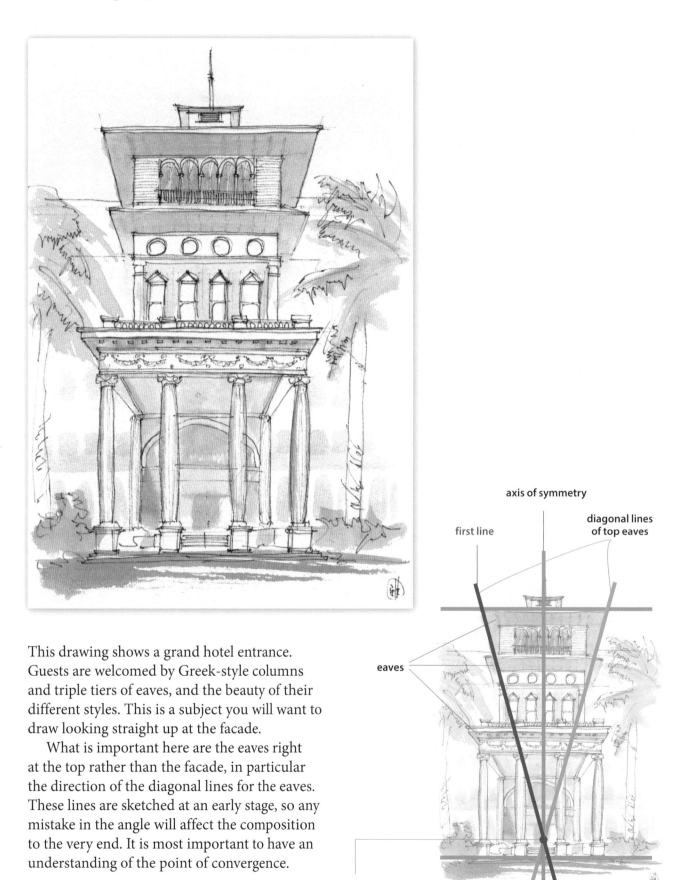

axis of symmetry

first line

diagonal lines
of top eaves

eaves

point of convergence

This drawing shows a grand hotel entrance. Guests are welcomed by Greek-style columns and triple tiers of eaves, and the beauty of their different styles. This is a subject you will want to draw looking straight up at the facade.

What is important here are the eaves right at the top rather than the facade, in particular the direction of the diagonal lines for the eaves. These lines are sketched at an early stage, so any mistake in the angle will affect the composition to the very end. It is most important to have an understanding of the point of convergence.

Sketch Line Order

1 Rough positioning

Before starting the sketch, roughly mark out the overall layout and composition. If you do not do this, you may run out of space on the paper while drawing.

2 Start

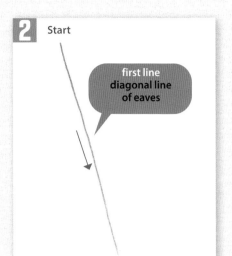

first line diagonal line of eaves

Draw a line for the eaves of the top floor. Here it runs from the left but it can be drawn from the right as well.

3

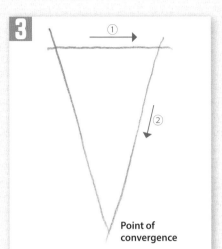

Point of convergence

Draw a line for the position of the eaves across the top floor, as well as the right side diagonal line. The lowest corner of this triangle is the point of convergence.

4

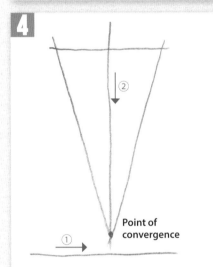

Point of convergence

Draw a horizontal line along the ground to connect the bases of the four Greek-style columns at the ground floor entrance.

5

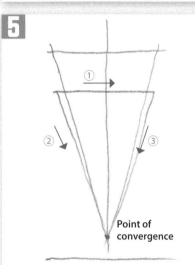

Point of convergence

Sketch the line of the eaves on the first floor in the same way as in steps 2 and 3. These diagonal lines run toward the same point of convergence.

6

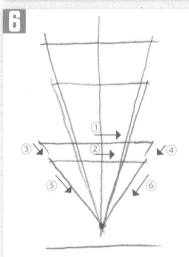

Sketch the eaves of the ground floor, which also acts as the roof. The shape is complex, so it is important to draw a line that acts as a guide.

7

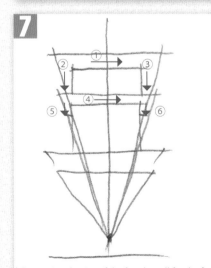

Determine the size of the facade wall for the first and second floors. Add symmetrical horizontal lines as well as lines on either side.

8

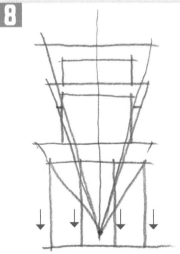

Add the positions of the four columns at the entrance on the ground floor. The center line (core) of each column is indicated by a line.

9

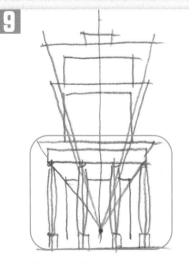

Sketch the relationship between the four columns on the ground floor, the wall behind them, the ceiling and window placement.

Looking up at a House on a Hill

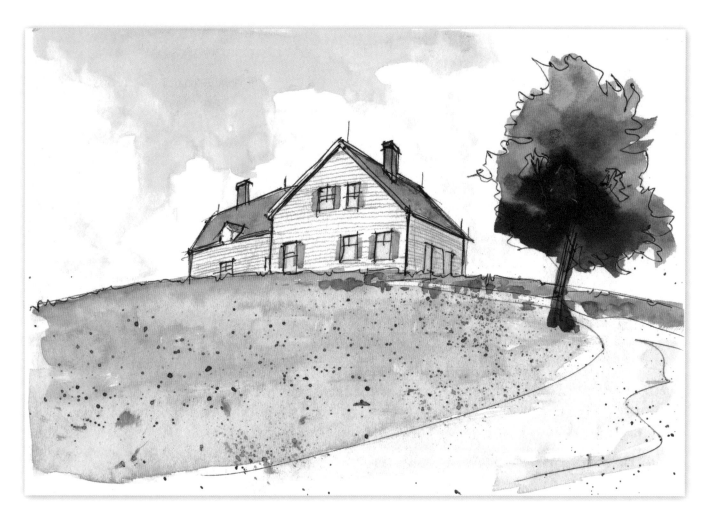

For roofed buildings, the angles of the roof's ridge and eaves are important. The line of the eaves runs toward the bottom right on the side of the house. Keep this angle in mind when you start sketching. Extend the lines of the roof ridge and eaves so that they intersect at one point on the right side of the paper. That is the point of convergence. Draw a horizontal line a short distance below the position of the building. This gap is the height difference between your eye level and the base of the building. It thus creates a composition where you are looking up.

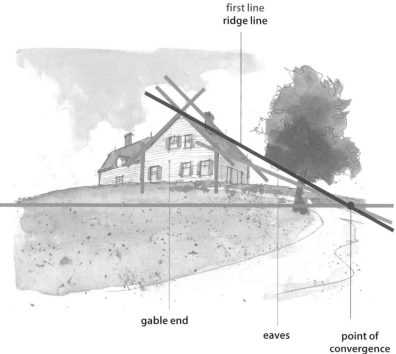

first line
ridge line

gable end

eaves

point of convergence

Sketch Line Order

Line direction

0 Rough positioning — Roughly sketch the overall image indicating the house, tree, grass and road.

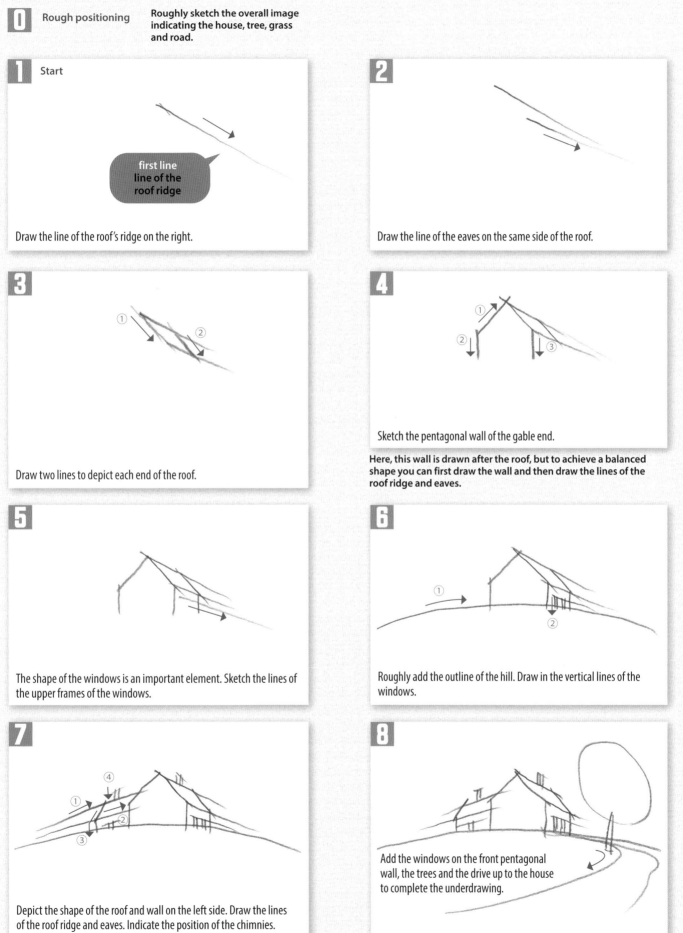

1 Start

Draw the line of the roof's ridge on the right.

2 Draw the line of the eaves on the same side of the roof.

3 Draw two lines to depict each end of the roof.

4 Sketch the pentagonal wall of the gable end.

Here, this wall is drawn after the roof, but to achieve a balanced shape you can first draw the wall and then draw the lines of the roof ridge and eaves.

5 The shape of the windows is an important element. Sketch the lines of the upper frames of the windows.

6 Roughly add the outline of the hill. Draw in the vertical lines of the windows.

7 Depict the shape of the roof and wall on the left side. Draw the lines of the roof ridge and eaves. Indicate the position of the chimnies.

8 Add the windows on the front pentagonal wall, the trees and the drive up to the house to complete the underdrawing.

Looking up at a Church

This technique is used when you are quite close to a building and sketching it while looking up.

A general rule is to choose iconic structures for compositions requiring an upward gaze. Although this is a small building for a drawing, it does have a steeple which adds interest. Key here is the relationship between the lines of the roof ridge and the eaves. It is a question of where on the paper the intersecting point of convergence will come when the lines are extended. Here, it is far outside and below the edge of the paper.

first line

gable end

The point of convergence is to the far left of the edge of the paper and low down.

Sketch Line Order

 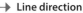

0 Rough positioning — Roughly sketch the overall image omitting any outlines.

1 Start

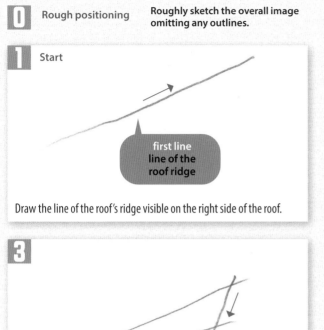

first line
line of the
roof ridge

Draw the line of the roof's ridge visible on the right side of the roof.

2

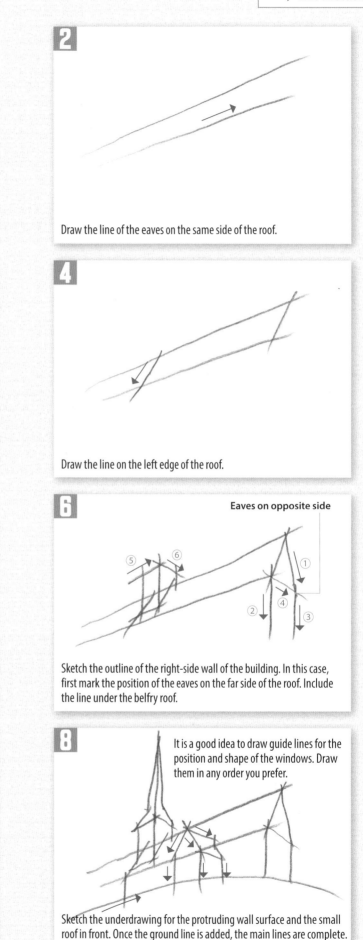

Draw the line of the eaves on the same side of the roof.

3

Draw the line on the right edge of the roof, which corresponds to the gable side.

4

Draw the line on the left edge of the roof.

5

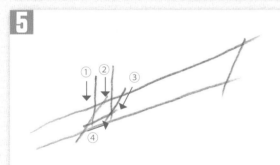

① ② ③ ④

Sketch the shape of the point where the steeple and roof intersect.

6 Eaves on opposite side

⑤ ⑥ ① ② ④ ③

Sketch the outline of the right-side wall of the building. In this case, first mark the position of the eaves on the far side of the roof. Include the line under the belfry roof.

7

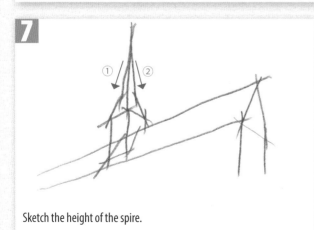

① ②

Sketch the height of the spire.

8 It is a good idea to draw guide lines for the position and shape of the windows. Draw them in any order you prefer.

Sketch the underdrawing for the protruding wall surface and line small roof in front. Once the ground line is added, the main lines are complete.

Looking up at a Torii Shrine Gate

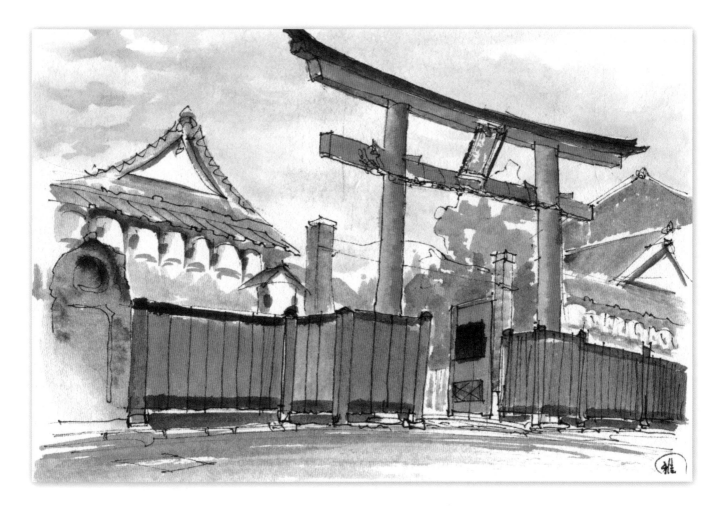

Because buildings are three-dimensional objects filled with interior spaces, they are usually depicted by combining the main roof and walls. However, some structures are not like that, for example, something constructed like an open framework. Rather than having walls, framework is a combination of structural parts like columns and beams. This is the case with the *torii* entrance gate to a Shinto shrine.

If you extend the center lines of the two horizontal parts to the right, it will create a point of convergence even though it will be beyond the edge of the paper. Mark the direction of the ground line connecting the base of the *torii* gate so that it also converges at this point.

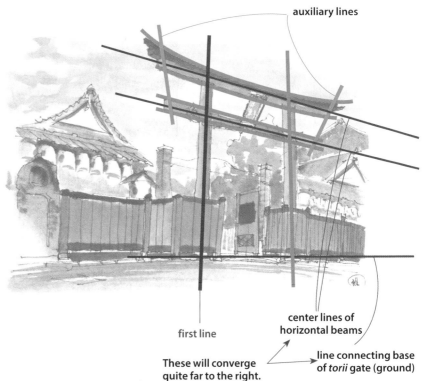

auxiliary lines

first line

center lines of horizontal beams

These will converge quite far to the right.

line connecting base of *torii* gate (ground)

Sketch Line Order

0 Rough positioning **Roughly sketch the overall shape and size of the gate.**

1 Start

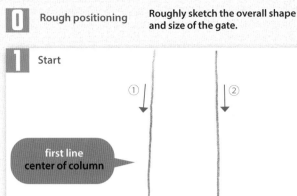

first line
center of column

Before drawing the outline of the two columns, draw a line to indicate the center, or core, of each one.

2

Draw the outlines of the columns.

3

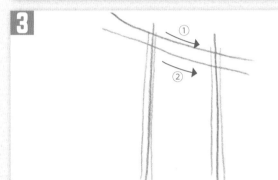

Draw lines as guides for the top horizontal beams. Both ends curve up slightly.

4

Draw lines as guides for the lower horizontal beam.

5

Draw auxiliary lines indicating the relationship between the left and right edges of the horizontal beams.

6

Draw the line of the ground. This is not a straight line, but is somewhat curved.

7

Add sketch lines for the detailed shapes of things, such as the edges of the structural parts and the ground, in order to convey the impression of looking up.

8

Sketch lines for the gateposts standing behind the *torii* gate as well. To complete the underdrawing, sketch the fence boards and shrine buildings.

Looking up at a Mountain

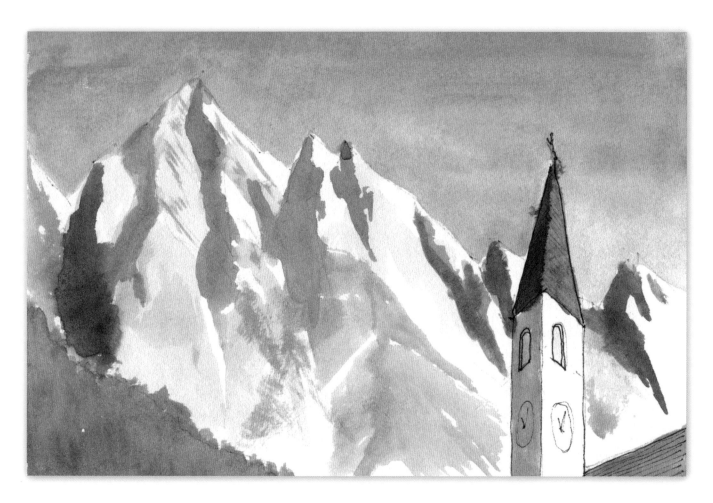

Generally, mountains have several ridges, although this depends on the overall shape of the mountain. Depending on how these ridges overlap, you can tell whether you are looking up at a mountain and also from which direction. The most effective way to draw a mountain is to incorporate some form of structure into the picture rather than drawing the mountain alone. In this drawing, for example, by adding a church steeple you can tell you are looking up at a mountain.

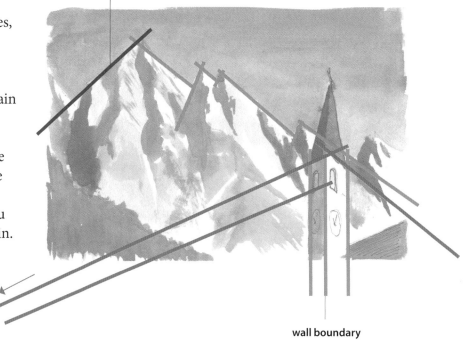

first line

point of convergence far to left

wall boundary

Sketch Line Order

0 Rough positioning **Roughly sketch the overall size and shape of the mountain.**

1 Start

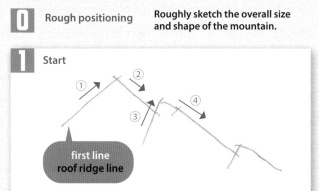

first line
roof ridge line

Sketch the lines of the main ridges of the mountain, keeping in mind their relationship with the church steeple.

2

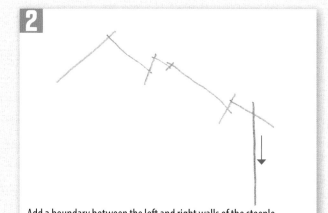

Add a boundary between the left and right walls of the steeple.

3

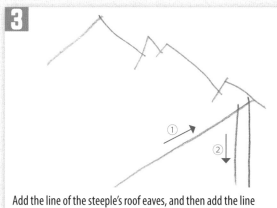

Add the line of the steeple's roof eaves, and then add the line depicting the steeple's left wall, which meets the roof eaves.

4

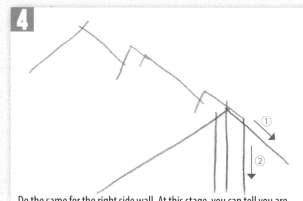

Do the same for the right side wall. At this stage, you can tell you are looking up at a mountain.

5

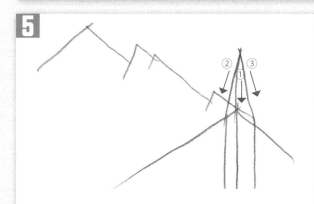

Sketch the steeple's steep roof with the spire on top.

6

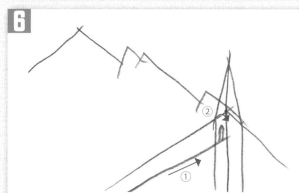

Sketch the windows. Take care with the angle of the windowsills. Start with the left side.

7

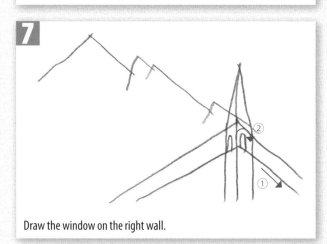

Draw the window on the right wall.

8

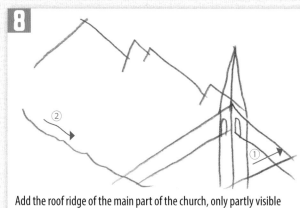

Add the roof ridge of the main part of the church, only partly visible here, as well as the trees in the foreground.

Looking down a Hill at a House

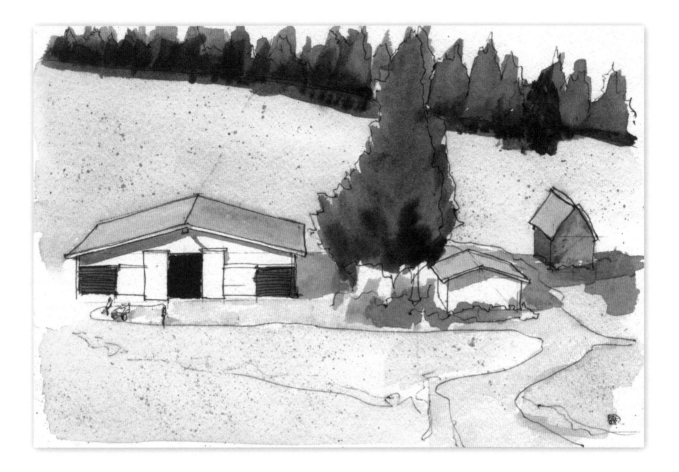

When looking up at a structure, the shape of the roof and, in particular, the direction of the eaves are important, but this direction becomes even more key when looking down. It is often difficult to see the shape of a roof when looking up from below. On the other hand, when looking down, you can often see the entire roof. The ridge and the eaves are the focus here.

Let us sketch this scene, assuming that all three buildings are parallel to each other.

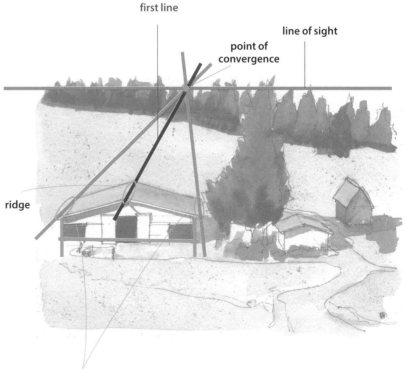

Sketch Line Order

0 Rough positioning — Roughly sketch the overall image of the house and adjacent buildings, omitting outlines.

1 Start

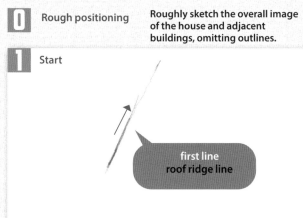

first line
roof ridge line

Draw a faint line to extend the line of the roof ridge of the house.

2

Point of convergence

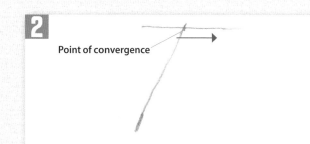

Draw a line on a horizontal axis. This is the line of sight and it will be slightly above the edge of the paper. The intersection of the lines drawn in steps 1 and 2 form the point of convergence.

3

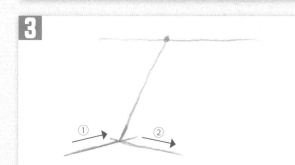

Draw the lines for the roof edge of the gable end at the front of the house.

4

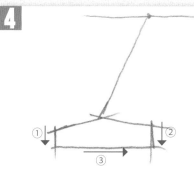

Draw the outline of the building facing front-on.

5

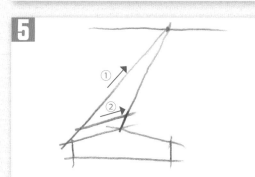

Draw a line in the direction of the background to depict the left side of the roof. Then, draw a line for the back side of the roof.

6

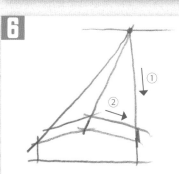

Sketch the right side. The lines drawn in steps 5 and 6 are directly affected by the point of convergence set in step 2.

7

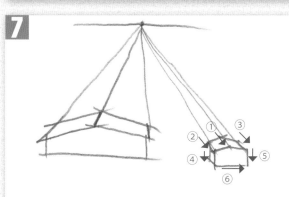

For the two small outbuildings on the right, sketch them in order. Start with the larger of the buildings.

8

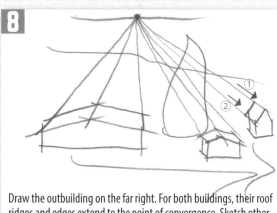

Draw the outbuilding on the far right. For both buildings, their roof ridges and edges extend to the point of convergence. Sketch other details like the trees and the path.

Looking down from High Ground

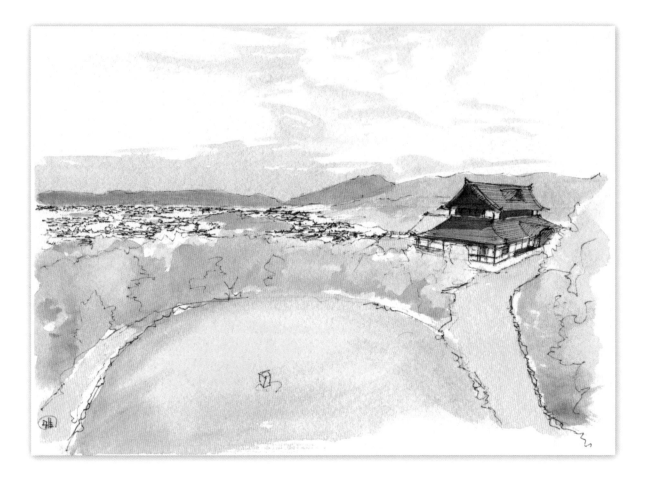

A picture looking down on a row of houses from a hill or high ground can have impact. However, this is quite an advanced technique. Here, I will explain how to sketch a picture showing a view looking down over a temple on high ground, and looking down even farther over a city. Even though there is only one temple building, it needs to be drawn carefully. If there is more than one building, say three or four, it is best to sketch them one at a time. This can be tedious and adds to the difficulty of the composition. Unlike previous subjects, draw fine lines to increase the accuracy of the intersections.

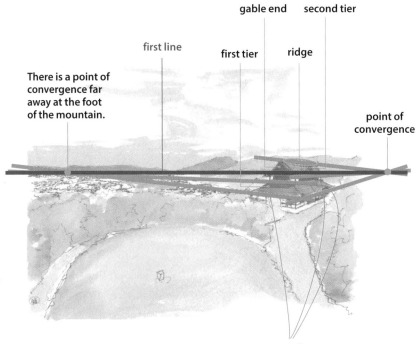

Sketch Line Order

Line direction

0 Rough positioning **Roughly sketch the overall image, omitting outlines.**

1 Start

point of convergence

> first line
> line of sight

Draw a horizontal line that extends to the far side. This is generally known as the line of sight. It is not a problem if you draw it slightly higher than the horizon.

2

Draw an extended line for the left side eaves on the temple's first tier tiled roof.

3

On the same layer, extend the line of the right side eaves. In traditional architecture, the corners of the eaves rise slightly, but here I have made them straight.

The point of convergence on the right side of the paper is slightly outside the edge. It is not unusual for this type of composition to have a point of convergence off the paper.

4

Define the four edges of the roof on the first tier. The temple building itself is small in this composition, but pay attention to the lines and depict the shape. Start by drawing the left side.

5

Next, draw the right side.

6

Continue by moving on to the second tier of the temple's tiled roof. Sketch the outlines of the gable end.

7

Extend the temple's top ridge line to the right. It will slant somewhat downward.

8

The main sketch lines have been drawn in steps 1–7. Add more details to flesh out the picture.

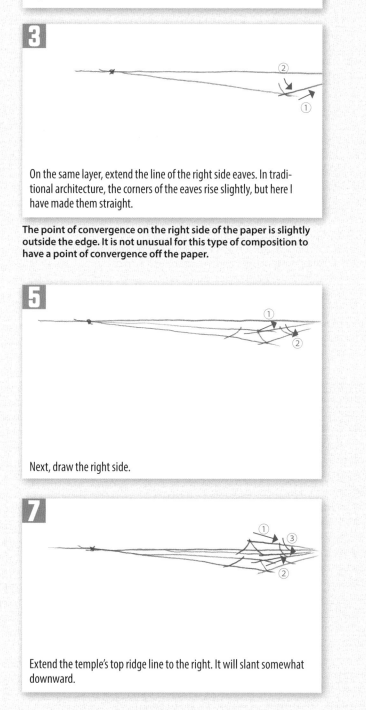

Looking down from a Tower

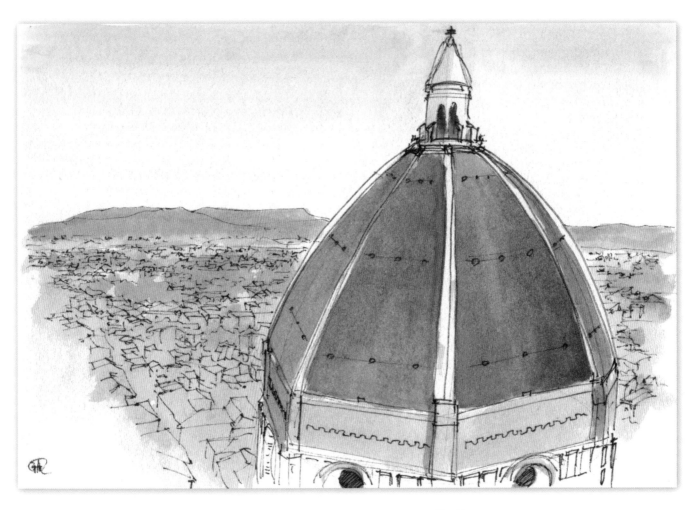

In this composition, an octagonal dome rises above the city. It is viewed looking down from an adjacent bell tower. Below each section of the curved octagonal dome is a horizontal rectangular panel (labeled sides A–D in the drawing to the right). Because of the perspective, the upper and lower edges of the rectangles used at the base of the dome should meet at a point of convergence far beyond the edge of the paper. It is important to keep in mind that these lines should eventually converge.

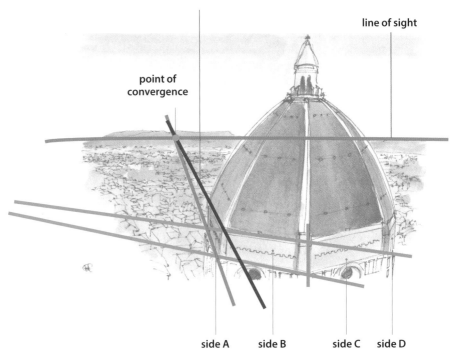

first line

line of sight

point of
convergence

side A side B side C side D

Sketch Line Order

1 Rough positioning

In order to accurately draw a line running toward the point of convergence, first sketch a rough outline of the shape and positioning of the dome.

This rough outline will be present throughout the sketch, but to avoid complicating the sketch it is not shown from step 2 onward.

2 Start

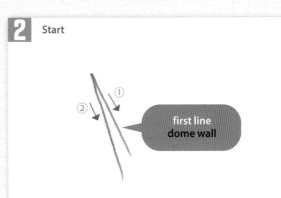

Start by sketching the left wall of the dome base. The direction of this diagonal line is crucially important.

3

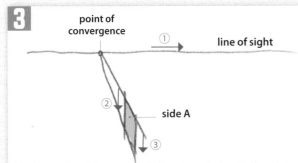

The intersection of the two straight lines drawn in step 2 is the point of convergence. The horizontal line passing through that point is the line of sight, so draw a line to give you an idea of it. Add vertical lines to the panel to create the rectangle (side A).

4

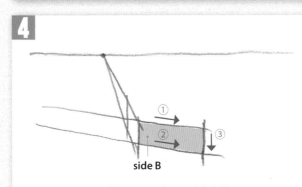

Do a simple drawing of the rectangular panel (side B) next to it. There is a point of convergence to the far left, and the top and bottom lines run toward it.

5

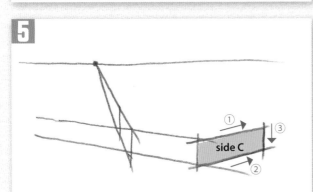

Repeat the drawing for the rectangular panel on the right (side C).

6

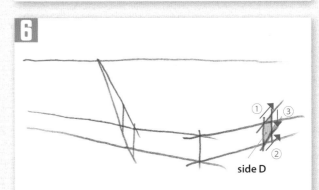

Draw the panel (side D) that is visible on the far right.

7

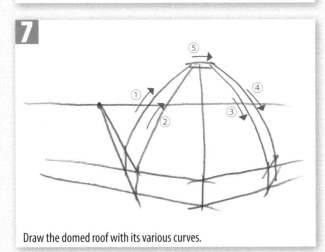

Draw the domed roof with its various curves.

8

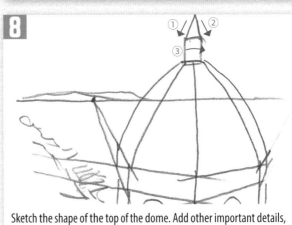

Sketch the shape of the top of the dome. Add other important details, such as the outlines of the buildings in the distance.

Looking down over a Coastal Village

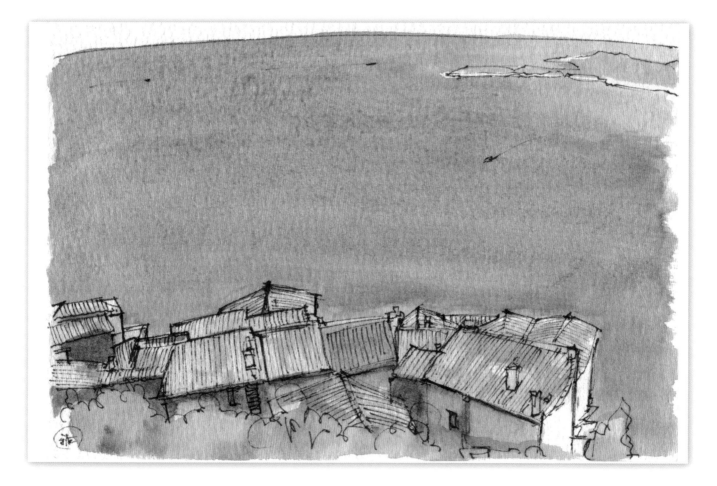

The subject of this drawing is a densely packed village on a small mountain overlooking the sea some 1,000 feet (300 meters) below. Looking down, you can see the vast expanse of sea and the horizon far beyond. Skill is needed to convey this magnificent view both horizontally and vertically. To begin with, it is important to place the horizontal line accurately on the paper. If, like in this example, you set the horizontal line as high as possible in the composition, it will make the angle looking down steeper, thus giving a sense of height. For the roofs of the houses, it is also important to have the lines of the ridges and eaves running toward a point of convergence.

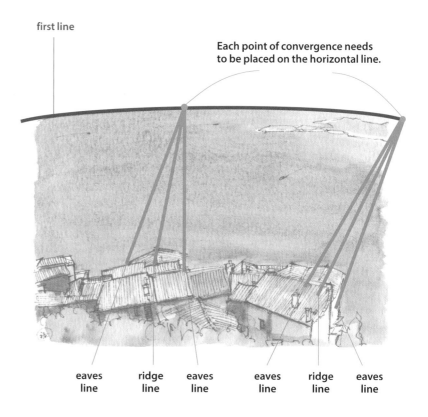

first line

Each point of convergence needs to be placed on the horizontal line.

| eaves line | ridge line | eaves line | eaves line | ridge line | eaves line |

Sketch Line Order

→ Line direction

1 Start

Start by marking the horizon. Draw a curved line here, without fixing the exact position.

2

point of convergence

The roof of the house on the far right is gabled, so extend the line of the ridge to find the intersection with the horizon. That is the point of convergence.

3

Extend the line of the eaves. They all lead toward the same point of convergence.

4

Sketch the outlines of the surrounding roofs.

5 point of convergence

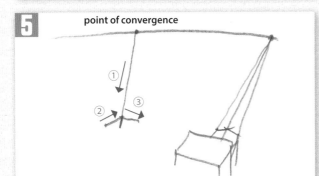

Extend the line of the roof ridge for the house that sits slightly to the left of center in the village (the gable end faces the horizon). This also runs to the point of convergence on the horizon.

6

Extend the eaves lines of the same house.

7

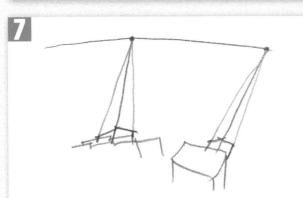

In the same way as in step 4, add the lines for the roofs of the adjacent houses.

8

In this composition, three points of convergence can be found following the roofs to the horizon.

Defined by the First Few Lines: Bridges, Steps, Mountains and Rocks

In this chapter, I have put together a selection of subjects not covered in the explanations so far.

Bridges are structures like buildings, so the concept for sketching these is almost the same, but for a building there is no question about which side is the facade. The challenge with bridges is to decide where the facade is located. This can make a difference in the way you draw the bridge.

Steps play an important role in buildings and plazas, so they are a subject that often gets included in compositions. If the steps are a small part of the entire composition, the details do not matter as much, but if they are the main focus, that changes things. Although I will only introduce one subject here showing that difference, you will see that I have drawn the lines for the composition in a lot more detail than for the previous examples. In addition, as the sketch line order is mostly fixed, you will not be able to correct this if you make a mistake partway into the drawing, nor will you be able to draw the correct lines after that. Drawing steps is unique because it involves a technique where the shape of the steps is replaced with a combination of jagged lines at the edges.

I also introduce how much detail to use to express mountain scenery using sketch lines, and how to position rocks when drawing them.

A Simple Stone Bridge

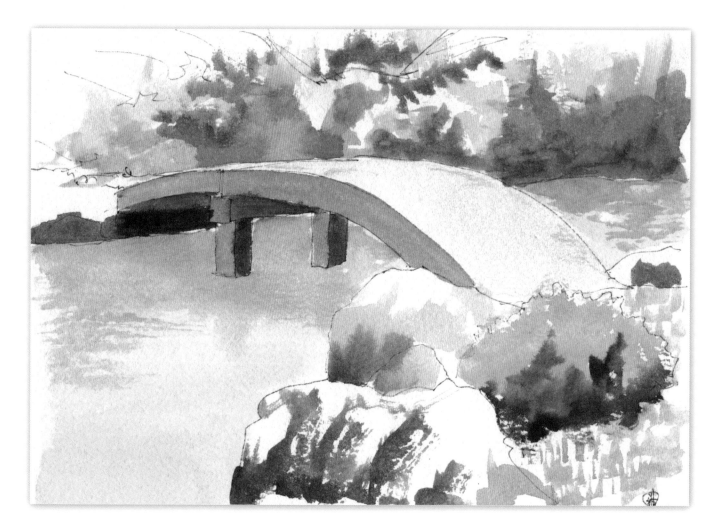

This is the type of graceful stone bridge commonly seen in Japanese gardens. It has a gently curving arch supported in the center by simple pillars with a sturdy slab laid on top. It may look like a very simple bridge to draw, but a series of basic techniques are necessary. When you face the near side of a bridge, the position of the pillars is in the center, but when looking at it from an angle, as here, the pillars will be slightly to the left. You may draw the positioning as you view it. The key point is step **3** where you draw the shift in the curve of the arch.

Include this support slab above the pillars.

first line

Sketch Line Order

1

first line
bridge arch

Sketch the curve of the arch on the near or visible side.

2

Indicate the amount of distance between the near or visible side and the rear or far side of the bridge in order to determine how much to change the curve of the back edge of the arch.

3

Draw a line to connect the two points created in step 2 to form an arch.

4

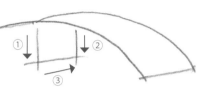

Sketch the position of the stone pillars below the center of the bridge.

5

Sketch the thickness of the span of the bridge.

6

Draw lines to show the three-dimensional shape of the pillars and the horizontal support slab resting on top of them.

7

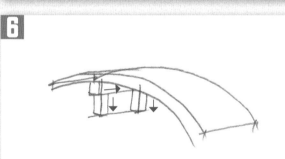

Add the line for the edge of the pond.

8

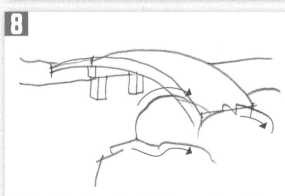
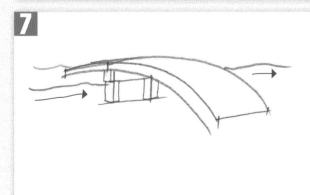

Roughly add the rocks and plants in the foreground. Lines with no numbers can be drawn in any order.

A Multispan Arch Bridge

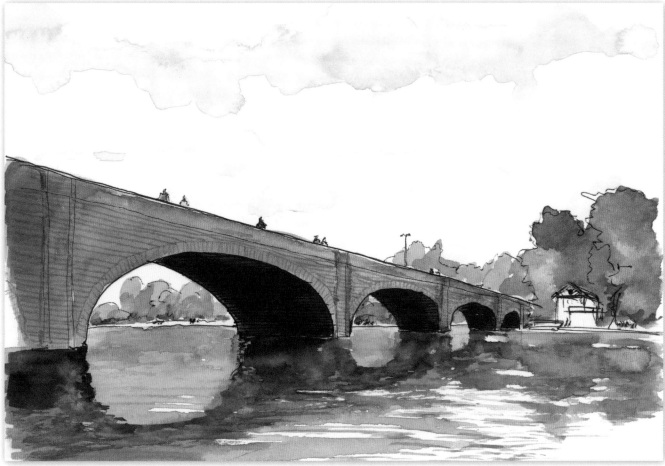

Full-scale stone bridges are another favorite subject for artists. If the spacing between the piers is the same but you are drawing them at an angle, the space will be wider in the foreground. There are more accurate techniques to draw bridges like this, but here I will introduce a simplified technique.

What is key is to mentally number the piers of the bridge from 1 through 5 starting on the left. Set the position of piers 1 and 3 first, and then determine the position of piers 2, 4 and 5.

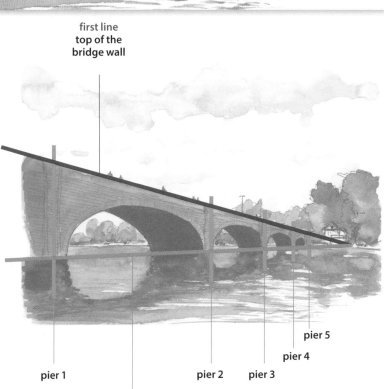

first line
**top of the
bridge wall**

pier 5

pier 4

pier 1

pier 2

pier 3

A line connects where the piers meet the water.

Sketch Line Order

1 Start

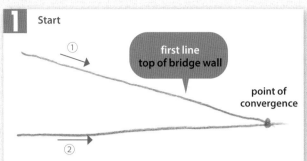

first line
top of bridge wall

point of convergence

Draw two lines, a line along the top of the bridge wall and a line connecting the piers where they meet the water. The intersection of the lines on the right forms the point of convergence.

2

pier 1

pier 3

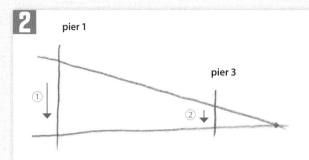

Mark the position of piers 1 and 3, keeping in mind the point of convergence.

3

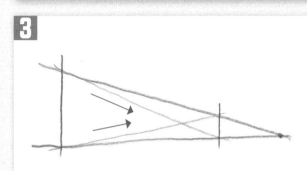

Draw diagonal lines within the trapezoid formed by the vertical lines that mark the positions of piers 1 and 3.

4

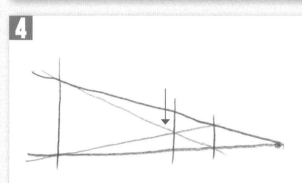

The vertical line that passes through the intersection of the diagonal lines marks the position of pier 2.

5

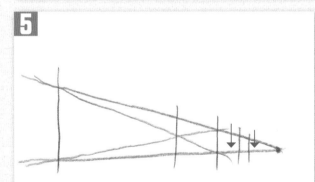

Determine the positions of piers 4 and 5 while taking into account the spacing between piers 1, 2 and 3.

6

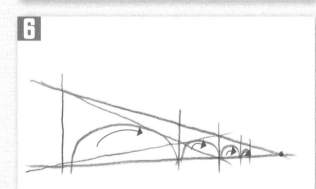

Sketch the curves of the arches.

7

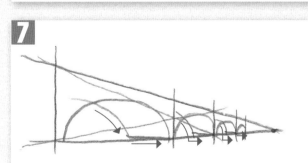

The shape of the arches on the opposite side of the bridge are also partly visible. Add those curved lines as if they are shifted across and running parallel to the curves drawn in step 6. Then, add the horizontal lines where the piers meet the surface of the water.

8

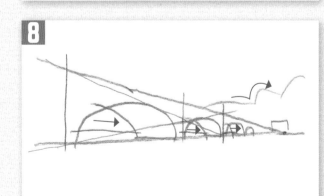

Complete the sketch by adding lines for the riverbank and trees in the far background. The lines with no numbers can be drawn in any order.

A Suspension Bridge

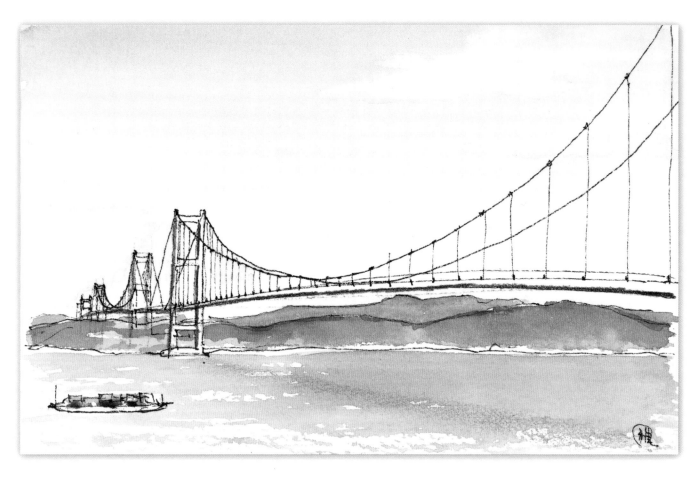

This is a technique for depicting a long suspension bridge with a tremendous sense of scale. The beautiful curves of the two main suspension cables are a striking feature. Once you have drawn the first curved line, draw the second curve almost exactly the same shape, but giving it the sense of being shifted slightly to the right.

The suspender cables are only drawn descending from the main suspension cable in the foreground.

Where the main cables in the background can be seen, draw them simply.

first line

Sketch Line Order

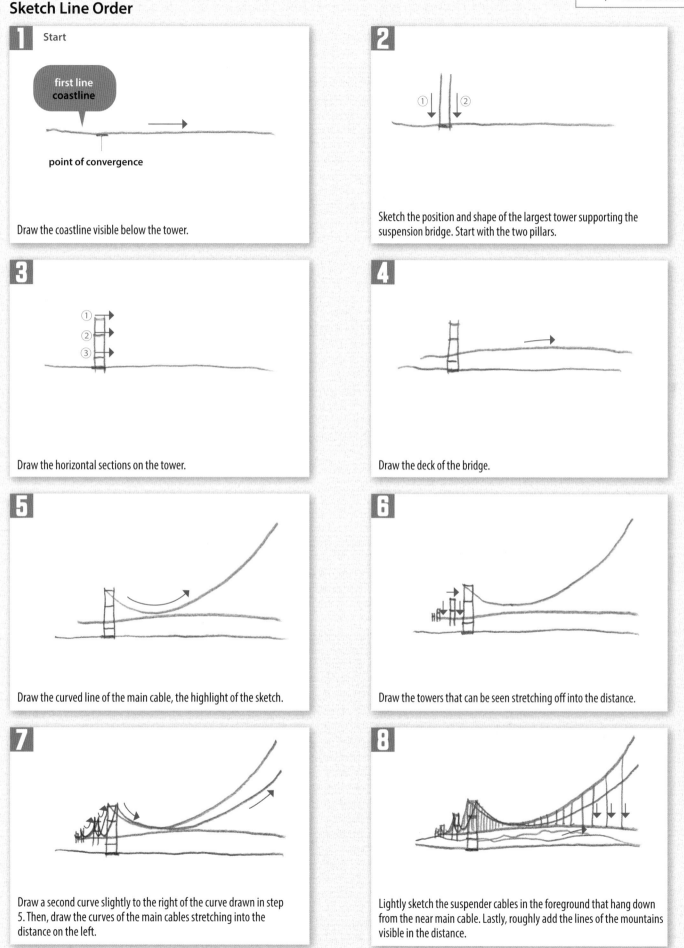

1 Start

first line coastline

point of convergence

Draw the coastline visible below the tower.

2

Sketch the position and shape of the largest tower supporting the suspension bridge. Start with the two pillars.

3

Draw the horizontal sections on the tower.

4

Draw the deck of the bridge.

5

Draw the curved line of the main cable, the highlight of the sketch.

6

Draw the towers that can be seen stretching off into the distance.

7

Draw a second curve slightly to the right of the curve drawn in step 5. Then, draw the curves of the main cables stretching into the distance on the left.

8

Lightly sketch the suspender cables in the foreground that hang down from the near main cable. Lastly, roughly add the lines of the mountains visible in the distance.

A Bridge Reflected in the Water

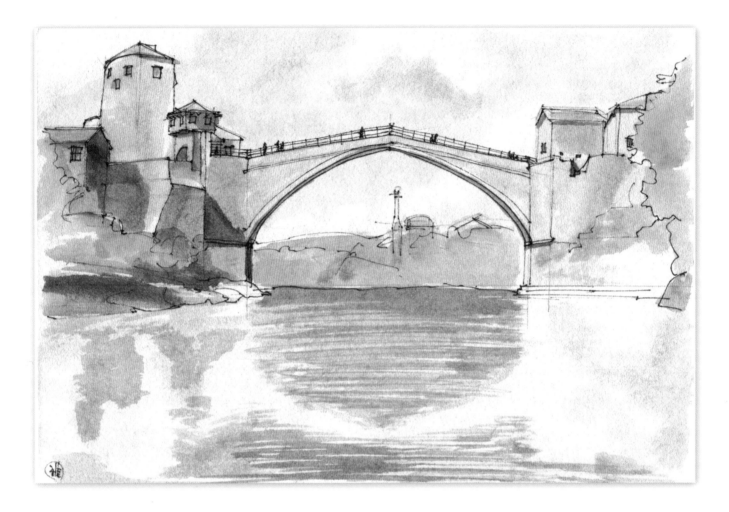

The shape of most bridges is identical on both sides even though the buildings at each end may differ. The landscape on each side will also be different. When drawing this type of composition, you will want to include the mirror effect where the bridge is reflected on the surface of the water. To do this, delineate the area for the water. When it comes to drawing the reflection, do not use precise lines, simply indicate the shape within the ripples on the water.

In this type of composition, the symmetry of the bridge is important, so add the axis of symmetry first.

Because this is a narrow bridge, it is quite difficult to depict its thickness.

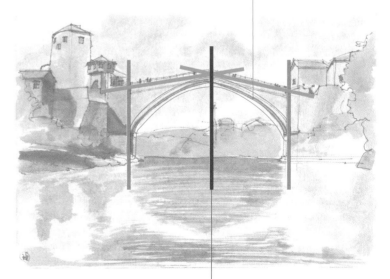

first line
axis of symmetry

Sketch Line Order

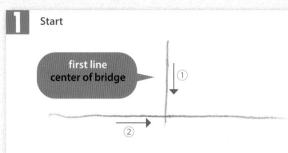

1 Start

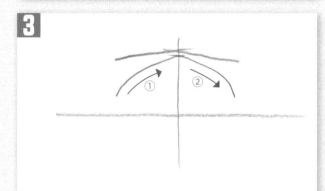

Draw a vertical line to mark the axis of symmetry in the center of the bridge and a horizontal line to mark the axis of symmetry for the reflection on the water.

2

Add slightly angled lines for the low bridge wall. Depending on the vertical position of this line, the reflected area may not fit properly on the paper, so take care.

3

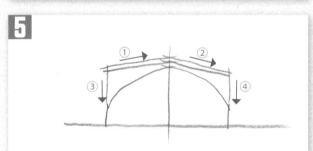

Sketch the curve of the slightly pointed arch.

4

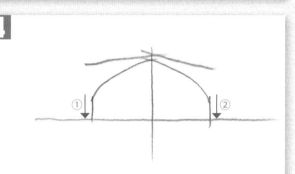

Add vertical lines for the parts that form the bridge piers.

5

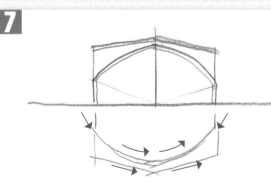

Add auxiliary lines, such as the lines for the top of the railings.

6

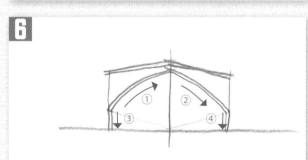

Draw lines to show the width of the bridge from the perspective of a pedestrian.

7

The shape of the reflection does not have to be precise. Start with the reflection of the arch itself.

8

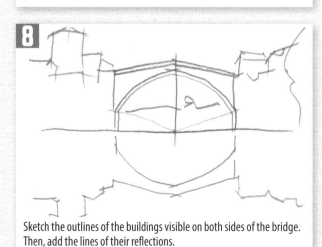

Sketch the outlines of the buildings visible on both sides of the bridge. Then, add the lines of their reflections.

Steps

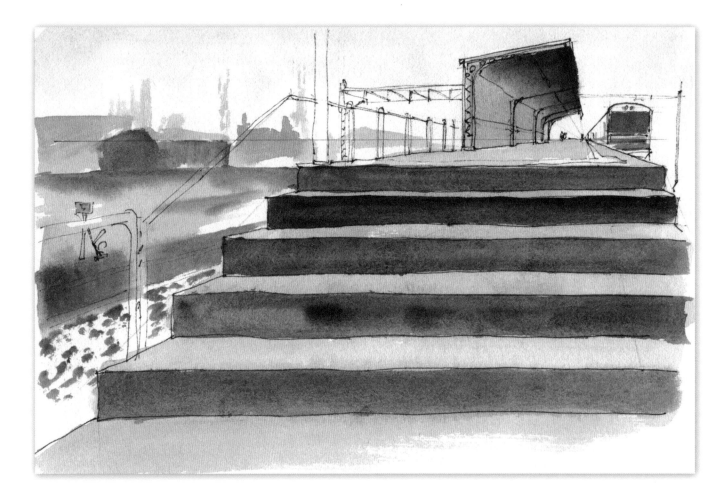

Steps are often included in compositions like outdoor plazas, the gentle rolling grounds of temples, the foot of bridges and at building entrances. It is no problem to simply draw horizontal lines to indicate steps, but a different technique is required if you want to draw the difference in height and convey the spatial expression. Techniques for creating depth are useful when drawing steps.

Here, I describe the essential skills needed for drawing steps leading to a train station platform. Such a composition requires a number of different sketch lines.

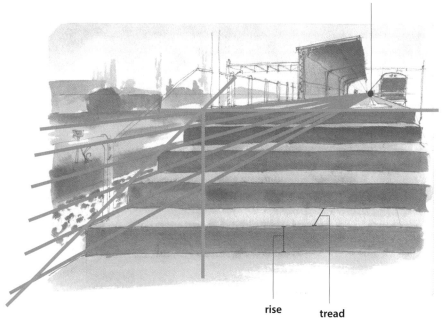

first line
point of convergence

rise **tread**

Sketch Line Order

1 Start

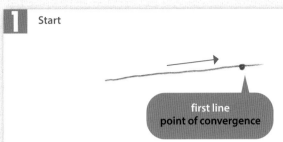

first line
point of convergence

Set a point of convergence in the far distance and draw a line that slopes gently down on the left to indicate the edge of the platform. The positioning of this angle will greatly affect the success of the picture.

2

Decide where the steps start to descend and draw a horizontal line from there extending to the right.

3

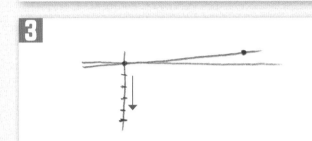

Draw a line and divide it into five sections to indicate the five steps.

4

Add a diagonal line that rises to meet the vertical line with the five demarcations. The degree of this angled line is determined by the area of the tread and the ratio of the rise, which changes with each step down, from narrower to broader.

5

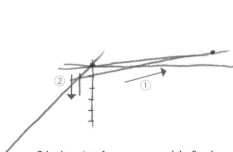

Take the point of convergence and the five demarcations from steps 3 and 4 and connect them in order. Using the diagonal line drawn in step 4, draw lines down from the intersecting points.

6

Repeat step 5 to sketch each of the five points in order.

7

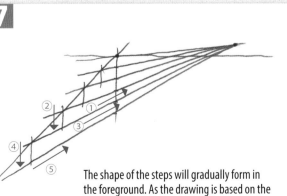

The shape of the steps will gradually form in the foreground. As the drawing is based on the intersecting points, if any point is slightly offset, it will become the wrong form, so be careful.

8

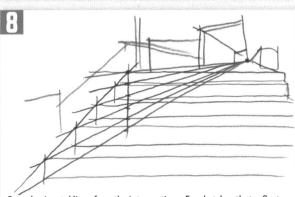

Draw horizontal lines from the intersections. For sketches that reflect a number of steps, as in this subject, it is best if you can position the lines like this.

A Towering Mountain

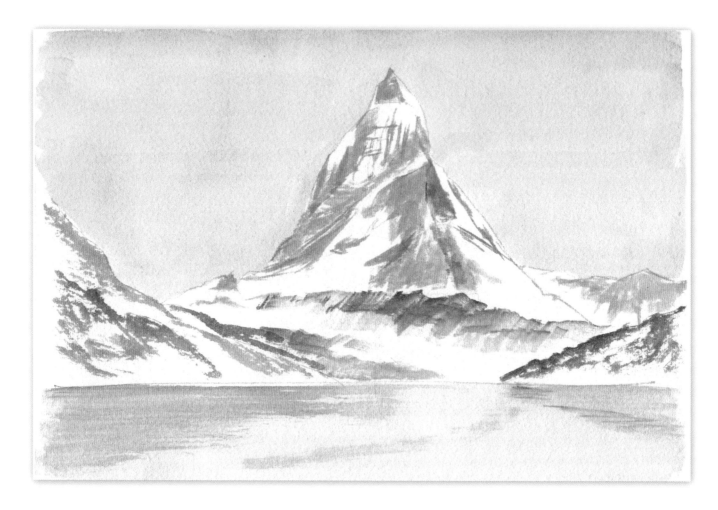

Mountains with unique sizes and distinctive peaks are relatively easy to sketch. Mountains can also create striking impressions due to their sharply formed rock faces and their almost sculpture-like three-dimensional shape. Generally, when looking at a mountain from a distance, it is easy to depict the outline and ridge lines of the mountain accurately.

Note that in this subject, the reflection of the mountain's shadow in the water in the foreground is not the main theme. Thus, the shoreline is set quite low on the paper.

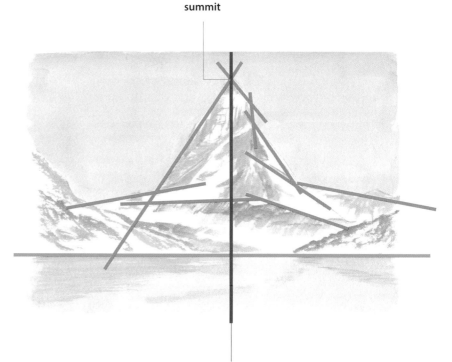

summit

first line

Sketch Line Order

1 Start

first line
vertical line
through the summit

Draw a vertical line running through the summit.

2

Think of the ridge line on the left as one straight line and draw it.

3

① ② ③

Draw the ridge line on the right in the same way as if it were composed of straight segments, with three drops along the way.

4

Form a right angle.

Add the shoreline. This will give the rough composition balance.

5

① ② ③

Add a ridge line that extends diagonally down in the direction of the arrows.

6

① ② ③

Draw the outline of the mountains in the foreground.

7

① ② ③ ④

Add lines for details that you want to include in the drawing.

8

① ② ③

Add the outline of the mountains on either side in the foreground to complete the underdrawing.

A Mountain Range

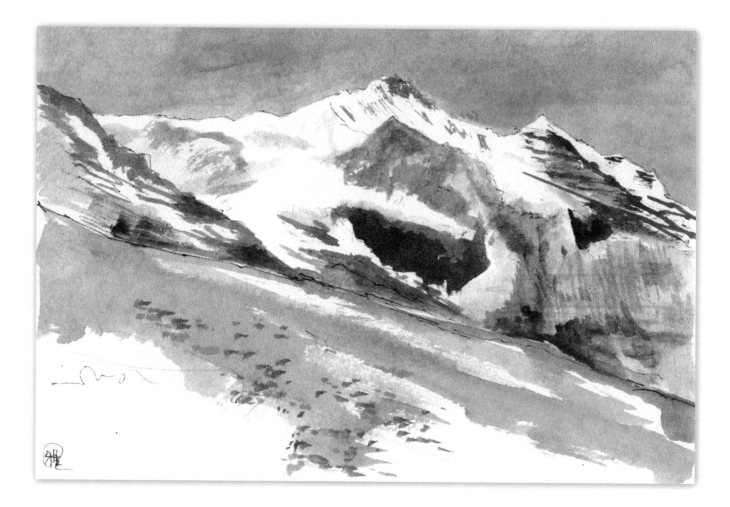

Man-made objects such as buildings are composed of linear and parallel elements. In contrast, natural elements found in mountains and other landscapes are irregular. While it is fine to depict the shapes of mountains roughly in an underdrawing, you need to make sure the ridgelines do not look artificial.

In this drawing, there are fewer sketch lines. Instead, the uneven shapes are expressed through touches of paint. Adding faint lines in pencil prior to painting will give you confidence.

first line
central mountain peak

Draw the ridge line of the mountain carefully.

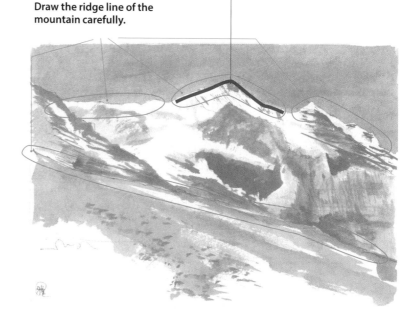

Sketch Line Order

1 Rough positioning

Roughly sketch the composition of the mountains and the sky, as well as the plateau in the foreground.

This rough outline will be present throughout the sketch, but to avoid complicating the sketch it is not shown from step 2 onward.

2 Start

first line
central mountain peak

Sketch the peak of the mountain seen at the center of the range. Although this is a sketch, it is good to depict fine details here.

3

Draw the ridge line on the left.

4

Draw the angular peak on the right and the ridge line extending from it.

5

Add a diagonal line at the border between the foreground and background.

6

Add a line where the unevenness of the rock face stands out.

7

② ①

Add more of the same types of lines.

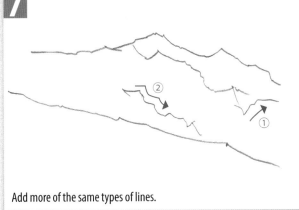

8

Add the diagonal ridge line of the nearest mountain on the left of the distant landscape.

Countryside and Mountains

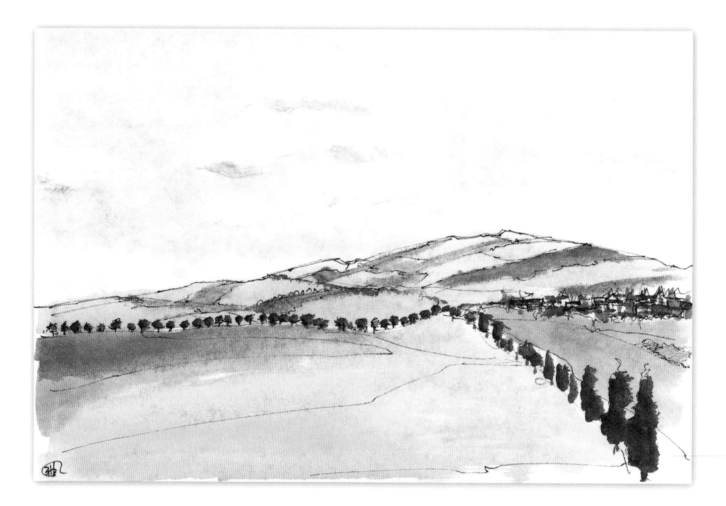

This drawing depicts a rural landscape with gently rolling hills and a mountain visible in the distance. For this type of subject, I focus on the tree-lined roads. The trees are generally all the same height, so you can express depth by drawing them taller in the foreground and shorter in the distance. The road runs from the right into the far distance and a road running from the left intersects with it partway.

In natural landscapes like this, the way the trees are positioned can convey perspective.

first line
far mountain

The farther away the trees are, the smaller they become to express perspective.

Sketch Line Order

1 Rough positioning

Draw the rough positioning of the mountain and land. Here, the ground and sky should have approximately the same area.

This rough outline will be present throughout the sketch, but to avoid complicating the sketch it is not shown from step 2 onward.

2 Start

first line
far mountain

Draw the outline of the mountain in the far distance.

3

Draw the outline of the smaller hill in the foreground.

4

Draw the tree-lined road that runs from the left side.

5

Draw the position of the road that runs from the right side foreground.

6

Mark out approximately three trees in the foreground, including their height.

7

Village

The sense of rolling pastures can be expressed by adding lines where the contour varies. A village is visible in the far distance on the right, so draw it simply.

8

Roughly mark the layout of the clouds floating in the sky. Use faint lines for these.

Placement of Rocks

A

When sketching a Japanese garden, there are times when the positioning of rocks is as important as the pond and plants. As very few details are present in rocks, you can enjoy the simple pleasure of sketching.

A depicts an arrangement of different-sized rocks. Creating layers of the same element in this way conveys the interesting shapes each rock has. Pay attention to how the outlines of the rocks are depicted, even in the sketching stage. Even if you do not draw many lines, you can convey the essential characteristics. Along with the outlines, mark out other lines, such as the boundaries between large surfaces.

B

A popular way to effectively arrange a small number of rocks is to juxtapose two contrasting ones. This means their different sizes, heights and shapes are used to distinguish them. In **B**, only two rocks in the stone garden are sketched. There are no sketch lines such as pen outlines; everything is simply colored with paint. However, using faint pencil lines to draw the outlines beforehand makes the rocks easier to paint.

If you want to emphasize a sense of space when positioning rocks, make good use of shading. Illustration C is an example of that. The shading of the rocks creates a clear three-dimensional effect. Two groups of rocks have been positioned along the diagonal axis of the paper, in this case bottom left to top right. Arranging the composition in this way means the limited size of the paper can be fully exploited. Although the main lines are expressed here using a pen, the shading is expressed using a combination of pen and paint. For the shapes of the rocks, I not only use a pen for the outlines but also for the boundaries between the surfaces. Just like depicting mountains, shading is useful to depict uneven surfaces of objects like ridges and valleys that are difficult to draw with lines.

"Books to Span the East and West"

Tuttle Publishing was founded in 1832 in the small New England town of Rutland, Vermont (USA). Our core values remain as strong today as they were then—to publish best-in-class books which bring people together one page at a time. In 1948, we established a publishing outpost in Japan—and Tuttle is now a leader in publishing English-language books about the arts, languages and cultures of Asia. The world has become a much smaller place today and Asia's economic and cultural influence has grown. Yet the need for meaningful dialogue and information about this diverse region has never been greater. Over the past seven decades, Tuttle has published thousands of books on subjects ranging from martial arts and paper crafts to language learning and literature—and our talented authors, illustrators, designers and photographers have won many prestigious awards. We welcome you to explore the wealth of information available on Asia at www.tuttlepublishing.com.

Published by Tuttle Publishing, an imprint of Periplus Editions (HK) Ltd.

www.tuttlepublishing.com

ISBN 978-0-8048-5623-2

SKETCH KAKIHAJIME NO IPPON
Copyright © Masao Yamada 2016
English translation rights arranged with
MAAR-sha Publishing Co., Ltd. through
Japan UNI Agency, Inc., Tokyo

English Translation © 2023 Periplus Editions (HK) Ltd.
Translated from Japanese by Wendy Uchimura

27 26 25 24 23 10 9 8 7 6 5 4 3 2 1
Printed in China 2305EP

Distributed by:

North America, Latin America & Europe
Tuttle Publishing
364 Innovation Drive
North Clarendon
VT 05759-9436 U.S.A.
Tel: (802) 773-8930
Fax: (802) 773-6993
info@tuttlepublishing.com
www.tuttlepublishing.com

Asia Pacific
Berkeley Books Pte. Ltd.
3 Kallang Sector, #04-01
Singapore 349278
Tel: (65) 6741-2178
Fax: (65) 6741-2179
inquiries@periplus.com.sg
www.tuttlepublishing.com